Elvis

CLOSE-UP

RARE, INTIMATE,

UNPUBLISHED

PHOTOGRAPHS

OF ELVIS PRESLEY

IN 1956

JAY B. LEVITON AND GER J. RIJFF

INTRODUCTION

BY KURT LODER

A FIRESIDE BOOK
PUBLISHED BY SIMON & SCHUSTER INC.
NEW YORK LONDON TORONTO
SYDNEY TOKYO

Copyright © 1987, 1988 by Ger Rijff and Jay B. Leviton
All rights reserved
including the right of reproduction
in whole or in part in any form
First Fireside Edition, 1988
Published by the Simon & Schuster Trade Division
by arrangement with the authors.
Simon & Schuster Building
Rockefeller Center
1230 Avenue of the Americas
New York, New York 10020
Originally entitled *FLORIDA CLOSE-UP,*
published by Ger Rijff, Tutti Frutti
Productions, Amsterdam, Holland
FIRESIDE and colophon are registered trademarks
of Simon & Schuster Inc.

Manufactured in the United States of America

10 9 8 7 6 5 4 3 2 1 Pbk.

Library of Congress Cataloging in Publication Data
Rijff, Ger J.
 Elvis close-up : rare, intimate photographs of Elvis
 Presley in 1956 / by Ger J. Rijff and Jay B. Leviton.—
 1st Fireside ed.
 p. cm.
 "A Fireside Book"
 1. Presley, Elvis, 1935–1977—Portraits. 2. Singers—
United States—Portraits. I. Leviton, Jay B. II. Title.
ML88.P76R5 1988
779′.978454—dc19 88-6743
 CIP
 MN

ISBN 0-671-66955-9 Pbk.

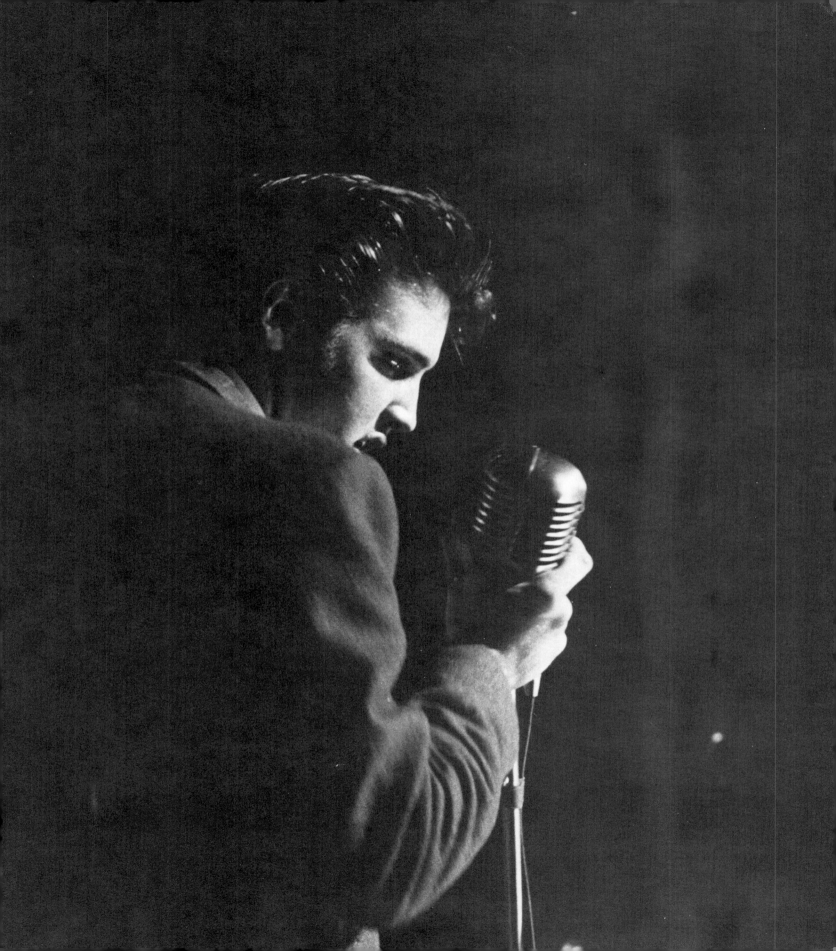

Once, in another world, Elvis Presley walked among us. He chowed down in diners, sang at the state fair, drove right down Main Street in his pink Cadillac. Elvis was social mobility personified: underway, rolling. And then, suddenly, he was gone. There was an explosion, you'll recall, and a great commotion, and when we looked around again, Elvis had disappeared into a cloud of Total Celebrity. We never really saw him again.

Some pictures were taken just before he vanished. You hold them in your hands. Many have never been published in this country before. They are pictures from Ground Zero, Year One, the epicenter of the Elvis Moment. They date from the end of summer, 1956, just about when the bomb hit.

It was a routine assignment for Atlanta photographer Jay Leviton. He had received a call from *Collier's* magazine in New York asking him to hook up with Elvis and his band—guitarist Scotty Moore, bassist Bill Black, and the recently installed drummer, D. J. Fontana—in Jacksonville, Florida, on August 10th, and to shoot the bejesus out of the tail end of their quickie nine-day Southern minitour, concluding in New Orleans on August 12th.

Elvis was already a sensation, of course, but a quite recent one—and, it was widely hoped in the fuddydud press, a passing one as well. At the beginning of the year, he had been simply a regional singer with five singles to his credit on the small Sun label out of Memphis. These records had heralded an electrifying new synthesis in American music, a fusion of white hillbilly boogie and raw black rhythm & blues. Elvis hadn't been the first white singer to record rock & roll: Bill Haley had placed the first rock hit on the national pop charts in 1953, with "Crazy Man Crazy," and in May 1955 had gone all the way to Number One with "Rock Around the Clock." Two months later, Pat Boone had duplicated that feat with his cover of Fats Domino's "Ain't That a Shame." But Haley was a stiff, stout, balding thirty-year-old, and Boone was a bad joke. Elvis's intoxication with black music, on the other hand, punched across with all the celebratory juice of youth, was itself intoxicating—an invitation to all who heard it to lighten up, loosen up, let a new age begin. On Sun Records, with Sam Phillips playing midwife, Elvis had given birth to rockabilly—had even had some hits, including a

country Number One. But by the beginning of 1956, he had yet to dent the national pop charts. That was about to change, however. Radically. Because Elvis had drawn the attention of a booking agent and all-round music-biz hustler who called himself Colonel Tom Parker. Parker, angling to become Elvis's manager, had engineered an astonishing $40,000 buyout of Elvis's Sun contract and, in November 1955, had delivered his boy to a powerful major label, RCA. On January 10th, 1956, two days after his twenty-first birthday, Elvis walked into RCA's Nashville studios and, over the course of two days, recorded five songs with a band beefed up by guitarist Chet Atkins, piano player Floyd Cramer, and a smooth vocal group, the Jordanaires. One of the numbers they cut, "Heartbreak Hotel," was released as his first RCA single two weeks later. Within a month, it had entered the pop Top Forty. By March, it was Number One. The Age of Elvis had begun.

"Heartbreak Hotel" topped the charts for eight weeks. Suddenly Elvis was everywhere. He made his TV debut on the Dorsey Brothers' Stage Show program, and ventured his first stint in Las Vegas (Squaresville: he bombed). Hollywood beckoned, and Elvis, a worshipper of James Dean, was thrilled. He auditioned for producer Hal Wallis and got signed to a three-picture deal with Paramount. Colonel Parker picked his first project, nixing *The Rainmakers,* with Burt Lancaster and Katharine Hepburn in favor of a western, *The Reno Brothers,* with Debra Paget and Richard Egan. "I've had people ask me was I gonna sing in the movie, and I'm not," Elvis said proudly. "I mean, not as far as I know."

By June, he was back at the top of the pop charts with "I Want You, I Need You, I Love You." On July 1st, he was in New York to introduce a new song on the Steve Allen TV show. In one of the most humiliating experiences of his career, he was forced to sing it, wearing white tie and tails, to a basset hound in a top hat. The next day, perhaps feeling more than usually fired up, he went into RCA's New York studio and recorded the new song, "Hound Dog," along with two others, "Don't Be Cruel" and "Any Way You Want Me." "Hound Dog" and "Don't Be Cruel" were paired for his next single. By the time he arrived in Florida to kick off the nine-day tour, it was the Number One record in the country. It would remain Number One for eleven weeks. Elvis was white-hot now, and uncontainable.

When Jay Leviton arrived in Jacksonville with his cameras, he found himself confronted with a new kind of celebrity frenzy. Neither Elvis himself

nor the shrewd Colonel seemed completely prepared to deal with it. Were such an eruption to occur today, all access to the cresting star—especially photographic access—would be severely limited. But in August 1956, the cultural clamor surrounding Presley was virtually unprecedented. Just riding it out was a full-time concern for the Presley camp. And so Leviton found himself, almost by default, left with near-total access to the King of Rock & Roll. "I was surprised Colonel Parker didn't control things more," Leviton says. "I don't think he sensed the full potential yet. So I just tagged along. It was like 'Go, baby.'"

For three crazy days, Leviton photographed Elvis everywhere: backstage, onstage, over dinner, even in bed. ("He was very casual, very unguarded.") Leviton had the extreme good fortune to be on the scene exactly as Presley's initial burst of fame reached critical mass, at that extraordinary moment just before the curtains of legend began to close around him. In the pictures

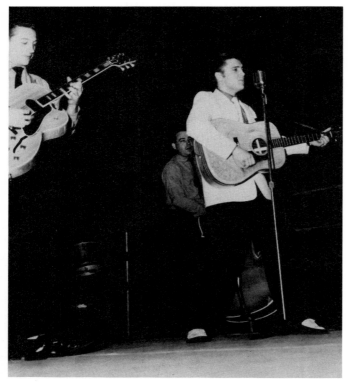

The band that shook America in 1955. Elvis Presley, Scotty Moore and Bill Black

presented here (*Collier's* folded before they could be run the first time around), we can still discern the sweet kid from East Tupelo, the onetime Memphis truck driver, the well-mannered young man at the root of the myth, on the brink of being utterly remolded in the fierce new fire of some unimaginable renown.

Ten days after the Florida tour ended, Elvis was in Hollywood, starting work on his movie. He was surprised to find that he would be required to sing in the film after all, that there was no interest in him as a straight actor, as another James Dean. The movie had a new title, too: *Love Me Tender.* By October its syrupy theme song had become his fifth Number One pop hit.

On December 4th, Elvis paid a visit to the Sun Records studio in Memphis, cradle of his artistic genesis. Sam Phillips was there, running down some tunes with Carl Perkins and his band. Jerry Lee Lewis, a new Phillips discovery, was sitting in on piano, and Johnny Cash was hanging around, too. Cash soon departed, but Elvis jammed for a while with the others, sitting at the piano and singing songs he loved—country tonks like "Crazy Arms," gospel favorites like "Lonesome Valley," pop schmaltz on the order of "There's No Place like Home." He had always been more than just a rockabilly, after all. More, even, than just the King of Rock & Roll.

In 1957, with the Olympian mists thickening, Elvis broke up his little band and stopped touring. He moved into Graceland, and it became his tomb. His hair was dyed black now, for the movies, but those didn't get any better. He gained weight, grew a bit grotesque, not unlike the rest of us. Still, his fame was unshakeable. It swelled and sprawled and swallowed him whole. He walked among us no more.

His musical legacy, of course, is intact: befuddling at some points, brilliant in the main. But there was more to Elvis than the vinyl artifacts that have survived him. For a fleeting moment in the fifties, he embodied the spirit of youth set free...before youth itself became just another marketing concept. He proved that pure talent and dreams could prevail over the forces of dread and social predetermination. He conquered the world but still called home on a regular basis. In short, he demonstrated the abundance of possibility at a time when all possibilities were said to be limited. It is hard to explain this—the Elvis Moment—to anyone who didn't live through it. These pictures remain, some tape clips, some kinescopes, and, for the most part, memories now dim, that grow dimmer with each passing Elvisless year.

ROCK 'N ROLL KING RULES 'ST. PRESLEYBURG

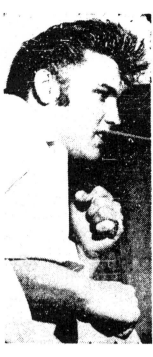
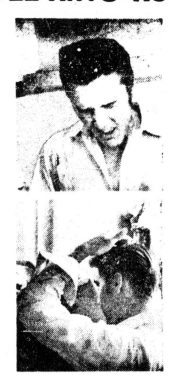
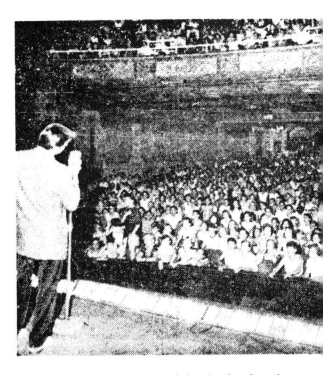

While being interviewed before his performance yesterday, Elvis Presley became captivated by an article about him in Monday's Times. Sparring like a fighter, Presley was caught by the camera fooling around with friends. A sneezing seizure hit him during radio interview and sent him rushing to the window for breath of fresh air. As time ar Presley combs his hair in preparation. At last, stage and is greeted with deafening screams and show.

Toughest Job, Police Say

Police, weary after a day of controlling six thousand Elvis Presley fans, said last night they had never before gotten an assignment as rough.

The Sunshine Festival parade in the winter they added, is the only previous occasion more officers have been called out for one event.

Police ranging in number from 13 to 20 controlled the crowds throughout the day, and at 8:30 the 25 members of the St. Petersburg Police Reserve Association cut short their regular meeting to assist at the Florida Theatre.

Several fire officials were on hand and one of them, Fire Marshal John Gidley, exclaimed, "I hope we never have anything like this again."

Police were outnumbered and outdone during the afternoon, when a heavy rain sent 2,000 teenagers — and many older people — surging toward a relatively small awning.

They had trouble again with crowds jammed against restraining ropes for Presley's 9 p.m. show, as the ropes gave way.

The newly-arrived reserves turned out in force to hold the pressing mob.

Six girls were treated for heat prostration and fainting spells by Fire Department Emergency apparatus shortly after 9.

Two police officers found a girl's torn slip on a front row seat after the 7 p.m. show crowd had left.

And police had their hands full with hysterical teenagers who ran weeping from the theatre after Presley had concluded his show.

"I can't stand it, I can't stand it," screamed a girl, about 15, to Patrolman Jim Krupp.

"I can't stand it either, but I'm not crying about it," said Krupp.

Patrolman Jim Liddle, who had gotten a Presley autograph for his sister, gave it to a teenager who pleaded to be allowed backstage so she could get her own.

None were allowed backstage and officers stopped 14 teenagers who tried to climb the fire escape to Presley's dressing room.

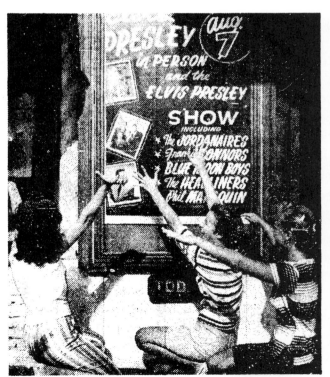
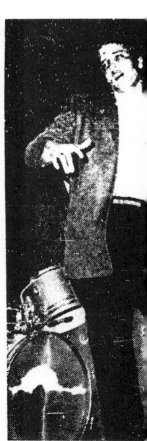

Three Elvisites praise pictures of the rock 'n' roll king as they await entrance to the Florida Theatre. Even photos brought sighs of ecstasy from the three young misses.

Elvis Came, He Sang And He Conquered

By ANNE ROWE and ARLENE FILLINGER

The pied piper of rock 'n' roll, a swivel-hipped, leg-lashing "entertainment bomb" blasted the downtown area into chaos all day yesterday. Screaming, fainting teen-agers lined the streets early to catch a glimpse of Elvis Presley, a rock-billy gyrating singer who's shattered show business with his sultry style.

He hit St. Petersburg with the effect of a small H-bomb, sending fans in mass hysteria and receiving an ovation rarely seen on the Suncoast.

Sixty-five hundred shrieking fans stretched the seams of the Florida Theatre to the breaking point at all the performances as they shoved, pushed and stampeded their way into the theatre. There they watched the boy — who rose from a $40-a-week truck driver from Mississippi to the number one name in show business today — slink and slide across the stage.

Although confusion and hysteria reigned over the mob, police had no trouble keeping it under control. Several faintings were reported, but no injuries occurred.

First in line yesterday morning were Clare Carter and Donna Bemis who set up housekeeping on the corner of First Avenue South and Fifth Street at 4:15 a.m., equipped with newspapers, Cokes, and an Elvis Presley fan book. They beat out two other enthusiastic Elvisites, Anne Muncy and Nila Shea, who arrived at 4:45 a.m. With long faces, Nila and Anne explained "we were the first in line to see him in Tampa and in Lakeland, but this time we missed out." The two blonde chums seem to be champion Presley pursuers in point of mileage. Nila saw him first in Atlanta while there for a swimming meet recently. (She holds the record for the free style 200-yard event in U.S. junior women's competition).

After seeing yesterday's first and last shows, the two girls planned to catch a bus to Orlando to see his performance there.

Other early birds were Glenda O'Brien and Donna Wyman, who arrived at 5:30 a.m., and Nancy Harper, Lin Peters, Joy Cliett who hit the sidewalk at 6:10.

CROWD DEFIES RAIN

Persons headed for work in the downtown district noticed a sizeable crowd by 9 a.m. Composed largely of feminine fans, the crowd was almost at its zenith at 11:50 a.m. when a half-hour downpour drenched clothes but not their spirit. At several instances the throng broke into a chant of "We want Elvis!"

Uniformed policemen kept tabs on the eager Elvis fans but they didn't have much difficulty keeping them under control.

Many DeCastro, special officer for the Tampa Police Department, kept crowds in order as fans lined the alley where Presley was to make his entrance, sporting his new white Lincoln Continental.

Doors opened ahead of schedule because of rain. The crowd swarmed in, but was kept pretty much in line by extra-duty policemen. Capt. C. G. (Robbie) Robinson said the initial impact of the crowd "was just like any bunch of kids all trying to get into the same place at the same time."

RECORDS PACIFY THEM

In their seats, Presley's fans were pacified by tape recordings of current hit records. Only occasionally did they clap in unison or shout for Presley.

Loud shrieks arose from the audience when a local announcer stuck his head out of the curtain and was mistaken for Elvis. At the slightest motion back stage, the shrieks were heard again.

Sitting front row center was an elderly woman who had feigned illness while waiting in line in order to gain early entrance to the theatre. She went

(Continued on Page 21)

(Continued from Page 19)

wild during the show. She was one of a surprising number of adults present.

WHAT ADULTS SAID

One adult, Mrs. Frank Dickie said: "I brought my 17-year-old niece, Jean Randall. She didn't want to come by herself. She's visiting here from Michigan."

Mrs. George Saunder and Mrs. M. A. Stewart came "just out of curiosity."

Tex Bobbitt brought his son Malcolm and said, "I'm getting a kick out of all this, too."

Mrs. Frank P. Caldwell Jr. "came with Pat Faulkner, a 17-year-old Presley fan, "but I'm thrilled to be here simply because he's famous."

"Wanted to see what all the teen-agers are so crazy about," said Dorothy Sauers.

Putting many miles behind her, Pat Aulger traveled from Detroit to see her idol, Elvis. "I think he's the 'most' even though my Uncle Al objects to him." Pat is visiting her aunt here.

'KILL THE SQUARE'

Although common courtesy was the key note throughout the two hours before Presley's presentation, the crowd jeered "kill that square" when a musical short featuring bandleader Louis Prima was shown on the screen.

Sitting patiently while the acts preceding Presley performed, the audience applauded Irish tenor Frankie Connors, shouted "go man, go!" while the Headliners blasted out their rendition of "Caravan," yelled appreciatively after Nancy Ford's singing of "Sing You Sinners," and laughed delightedly at Phil Maraquin, comic magician. Receiving the most ovation, second to Presley, were the Jordanaires, a singing quartet that backs Presley on many of his disks.

HOUSE GOES WILD

First sight of Presley was the sleeve of his kelly green sport coat . . . "and the walls came tumbling down!" The audience immediately rose en masse to its feet, screamed its welcome . . . and then went wild! The girls tore their hair, the boys looked more awed than impressed . . . hysteria reigned supreme . . . as did Elvis.

Like the cool cat that he is, Presley, arrayed in black pants, white shirt, white tie and buck shoes . . . and the kelly green

jacket . . . wormed and wriggled his way through seven numbers that kept his fans open-mouthed and screaming.

They shrieked their appreciation for the sexy Elvis, but at no time during his performance was it necessary for the police to take action. Presley rocked 'n' rolled with the mike, belting out his most famous songs. Teasing the audience with false starts, he finally broke in with "Heartbreak Hotel" and followed it with "I Was The One." Then came trouble . . . in the form of microphone difficulties. His went dead first, then when that was fixed, the Jordenaires singing with him, found themselves unheard. Seemingly under control, Elvis went on with his gyrations but made frantic motions of "help!" to stage hands nearby. At one point he asked for more "cord" because "I can't stand still when I sing." Despite his microphone difficulties, Presley's fans kept their attention on him with no let up. Apparently just seeing him was enough.

Elvis Is Draft Bait

What is Elvis Presley's draft status?

That is the big question confronting him now, too.

"I'm draft bait," he said yesterday. He registered with the draft board in Memphis and hasn't heard from the board since, he said, adding "and I hope I never do."

stage appearance, moment. He's on e as fans greet his

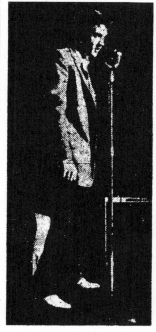

. . . cool, too . . .

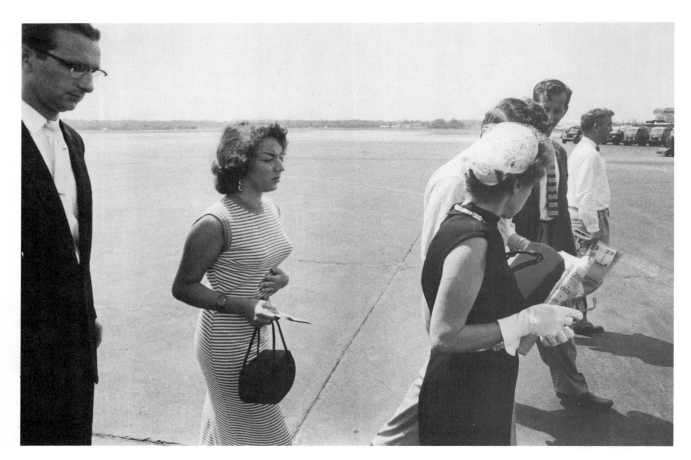

She'd had cramps something terrible during the flight from Atlanta to Jacksonville. She'd been nervous before that too, right from the moment she'd heard that she'd won the contest. Her father had teased her plenty when she sent in the answers to the "Win a Date with Elvis" contest in Hitparader, a magazine she bought whenever she had some spare cash. But he sure didn't say too much when she'd received the envelope addressed to Miss Andrea June Stephens, 895 Eden Avenue, Atlanta 16, Georgia. Of course she'd been on the phone for hours telling her friends but somehow that had only made the tension worse, till she almost couldn't stand it anymore. In the plane she'd just looked out the window without seeing anything really, and she'd secretly dreamed how he would be at the airport welcoming her. Instead when she got off the plane there was someone there from the State Theater where Elvis was to perform and he said his name was George Kreno or something. There'd been others too, but she'd been too excited to remember any of their names.

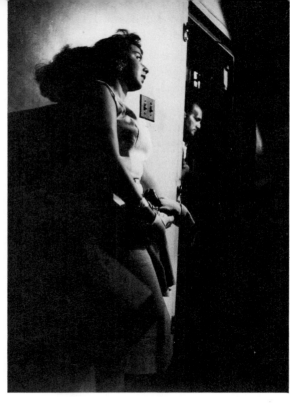

Then they took her off to the
hotel and told her she would
meet with him there. The wait in
the corridor outside his door
seemed the longest — then they
opened the door. There were so
many people in there, police
officers, photographers and
others that she didn't see him till
he got off the couch. And then he
called her honey and she didn't
know what to say, not even when
he asked her how the trip had
been. But he knew how to put
her at ease and talked to her like
he'd known her for years.

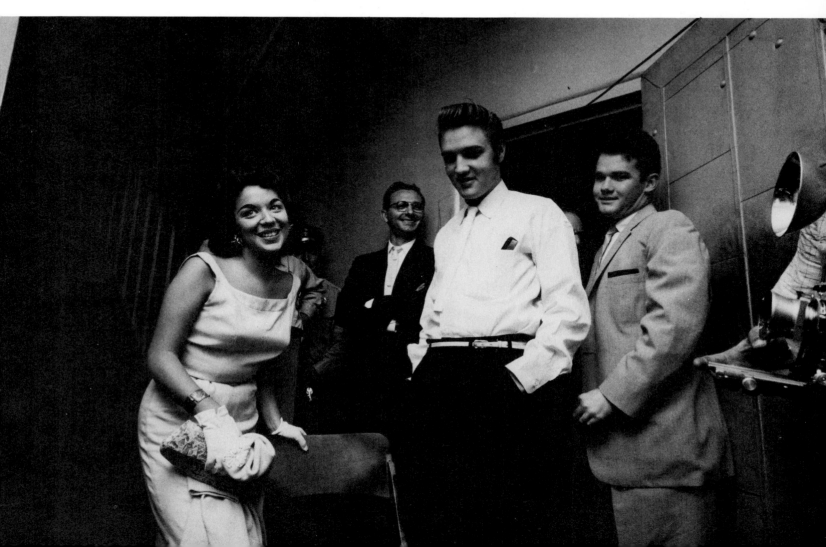

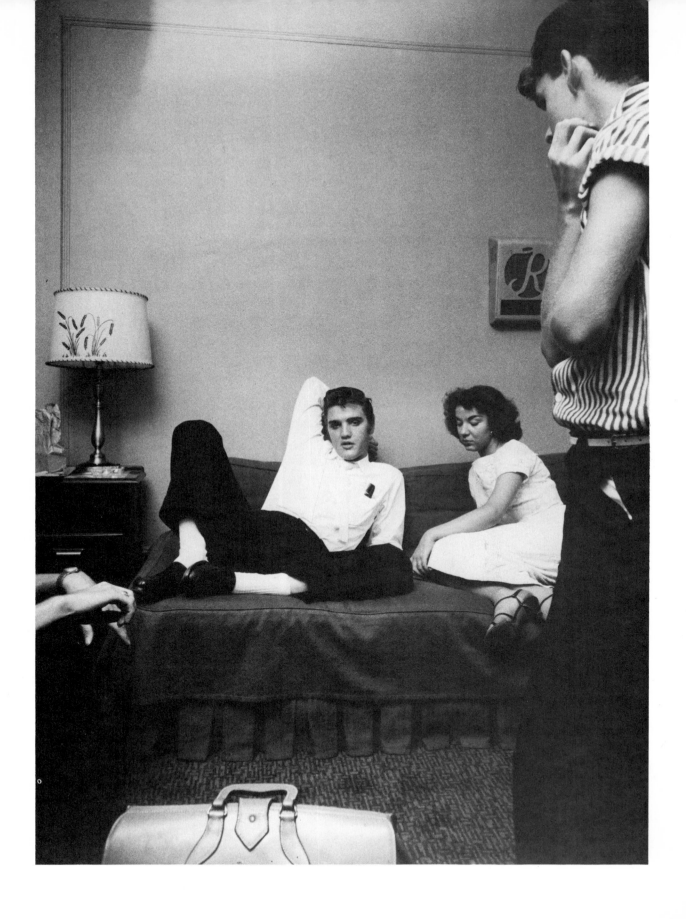

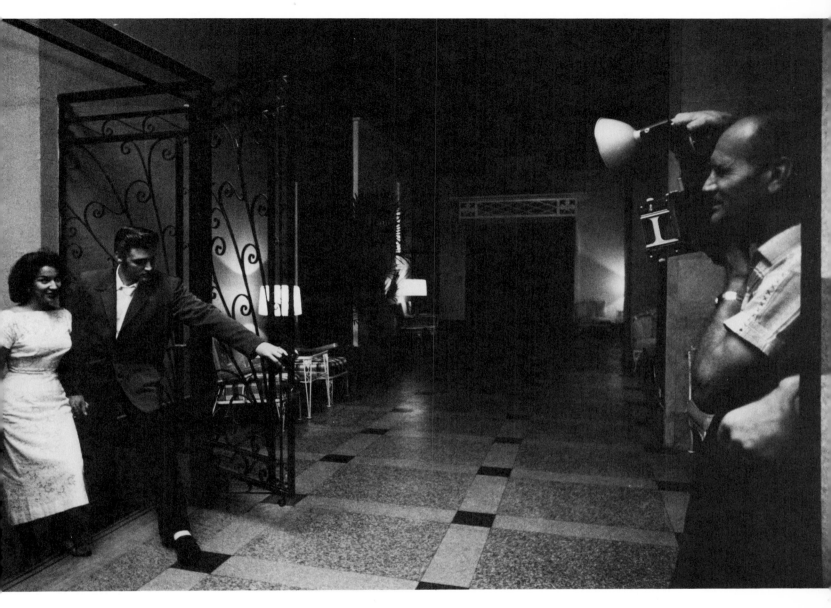

She only relaxed a bit when they sat on the sofa and she tried telling him how she loved his records. Then he asked her if she wanted to go out with him and get something to eat, cause after all she'd won a dinner date. And as they were just going out the hotel there was this girl standing there and when she saw Elvis she just fainted and had to be carried inside. Elvis was real worried about her and immediately sat down next to her on the couch and held her hand and talked to her so softly, calling her honey too. Suddenly there were lots of people standing round, so the girl must have been wondering where she was when she finally came to.

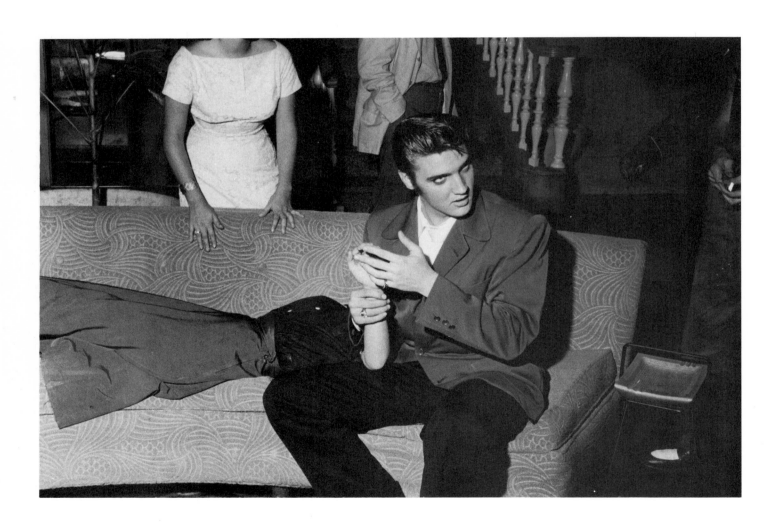

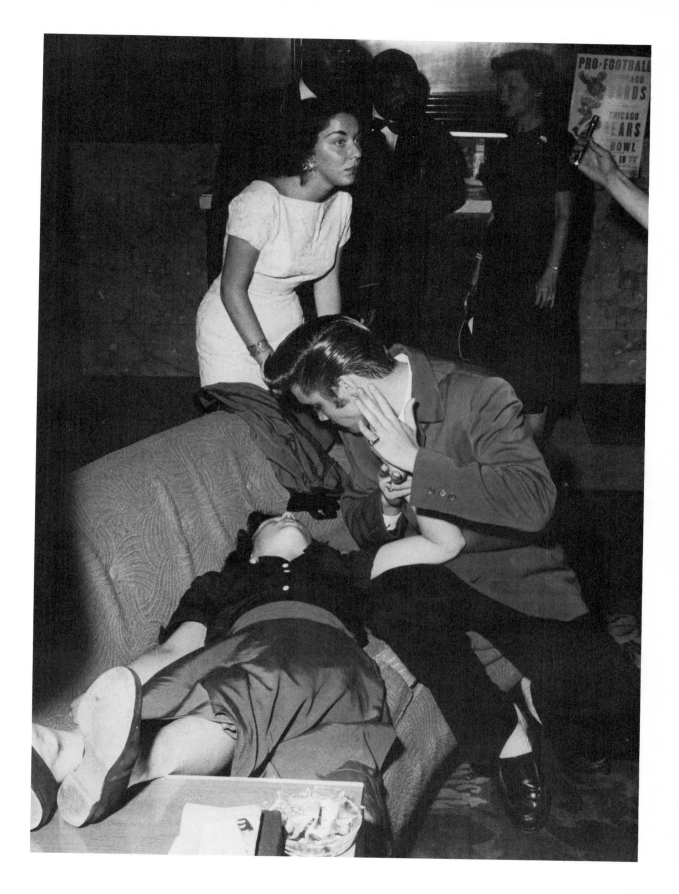

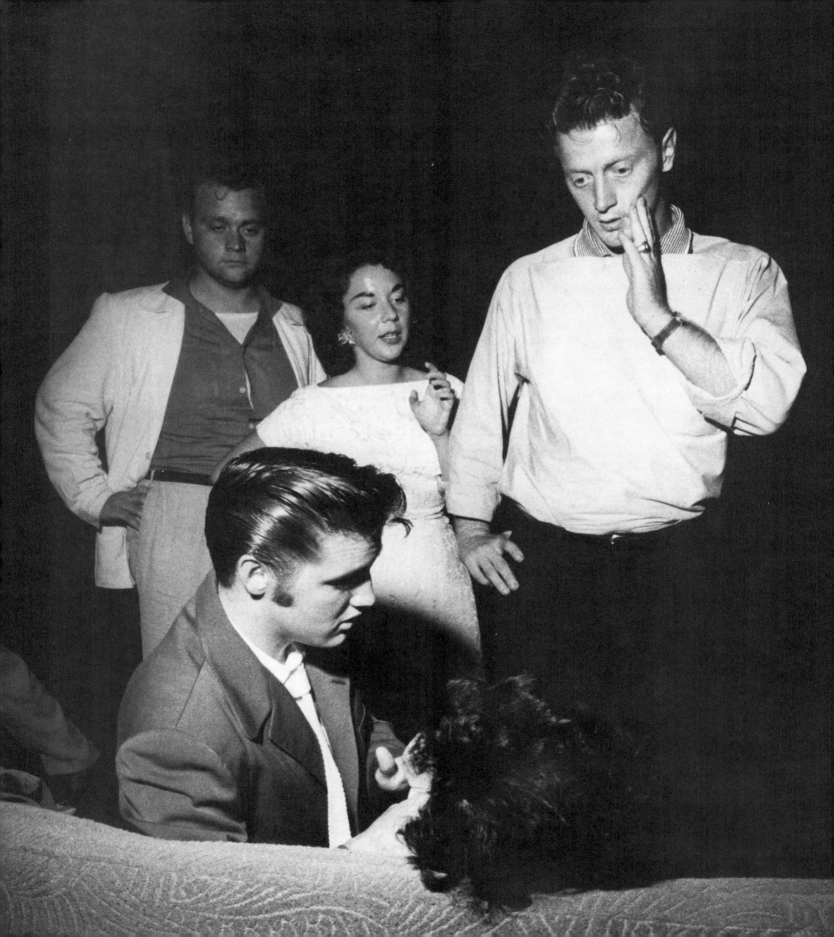

There was Elvis holding her hand
and all strange faces staring down
at her. But then everybody was
so nice and to show her how
worried he was he asked her if
she'd like an autograph. One of
his friends that he called Red
quickly got him a souvenir
program with his picture on the
cover and the girl was just
speechless when he signed it for
her and told her it was for her to
keep and please would she not
faint when she saw him next time
around.

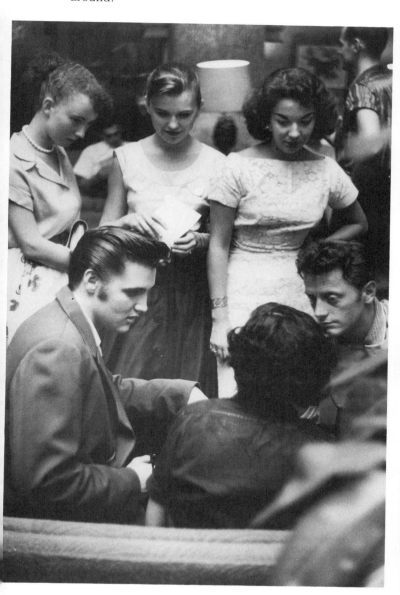

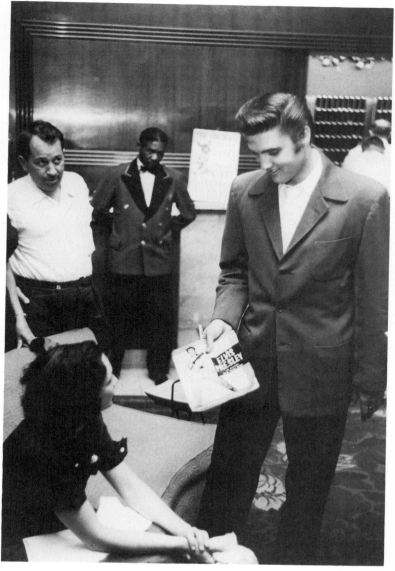

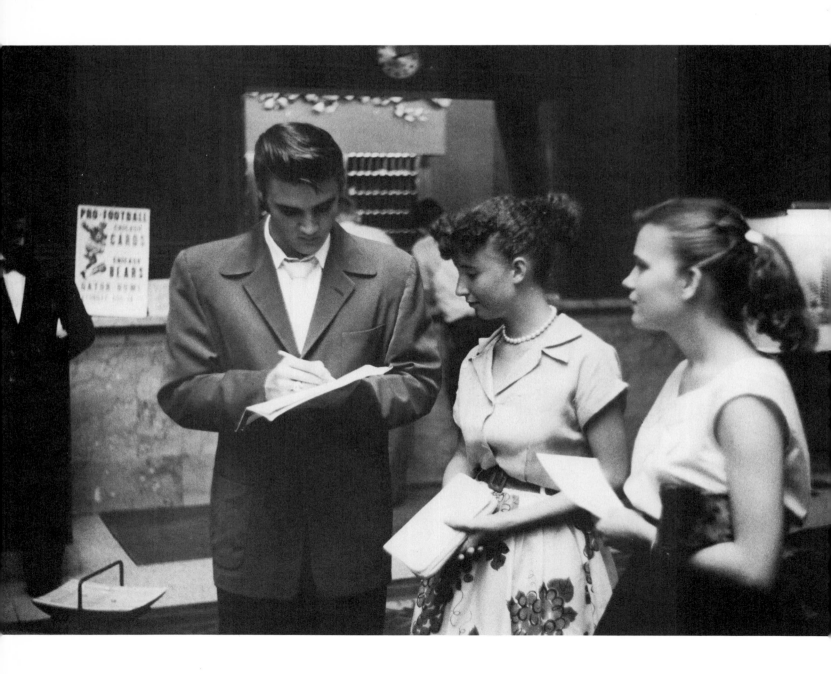

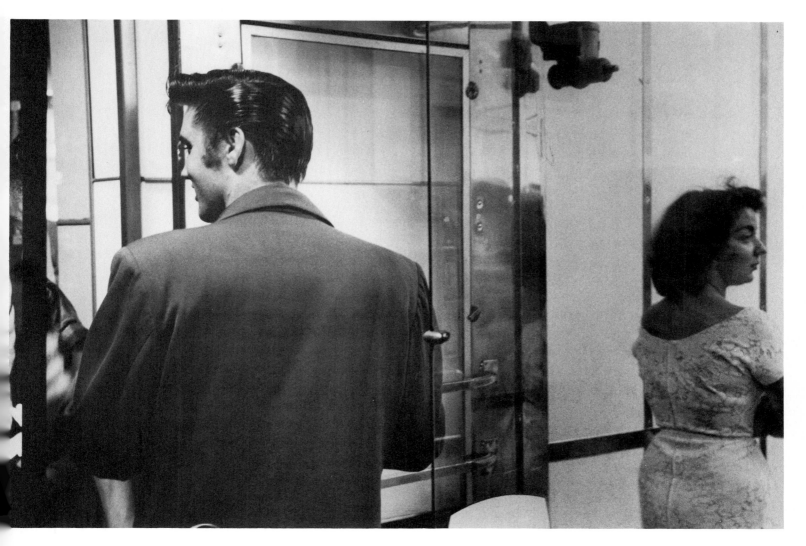

There were some other girls too and of course he said yes when they asked him for an autograph. He was just so nice to everybody and as he apologized to her for the delay and smiled so sweetly she almost wished she had fainted too. Now they didn't eat in the hotel but it didn't matter to her where they went just so long as she could be close to him. And then when they got to the place and he asked what she'd like she told him she wasn't hungry and told him to please go right ahead.

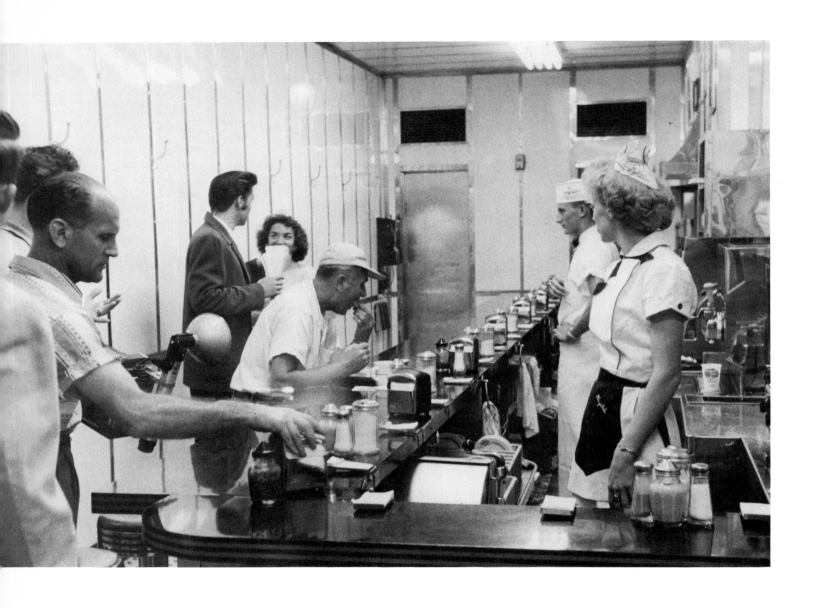

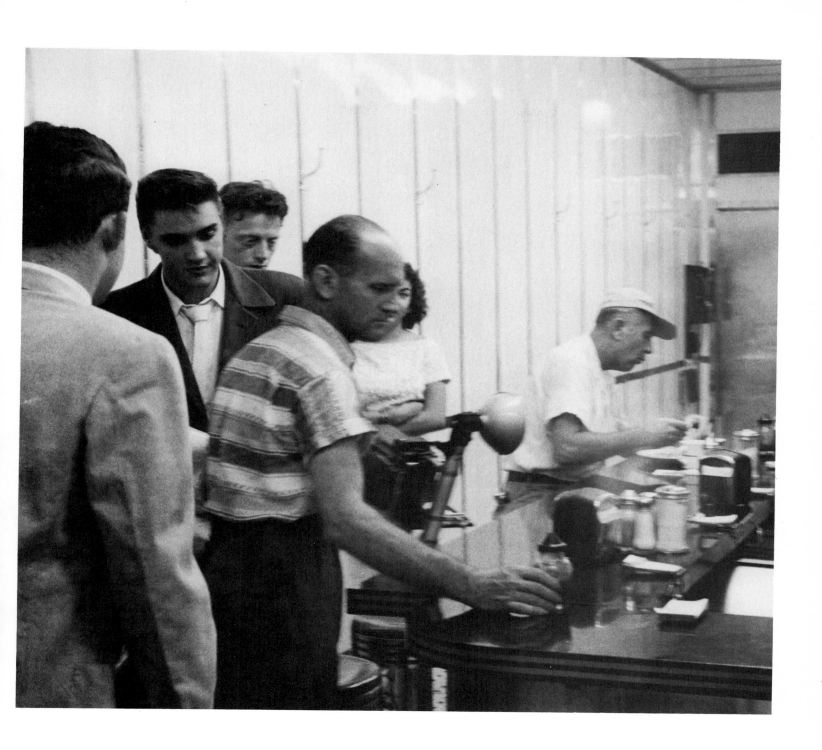

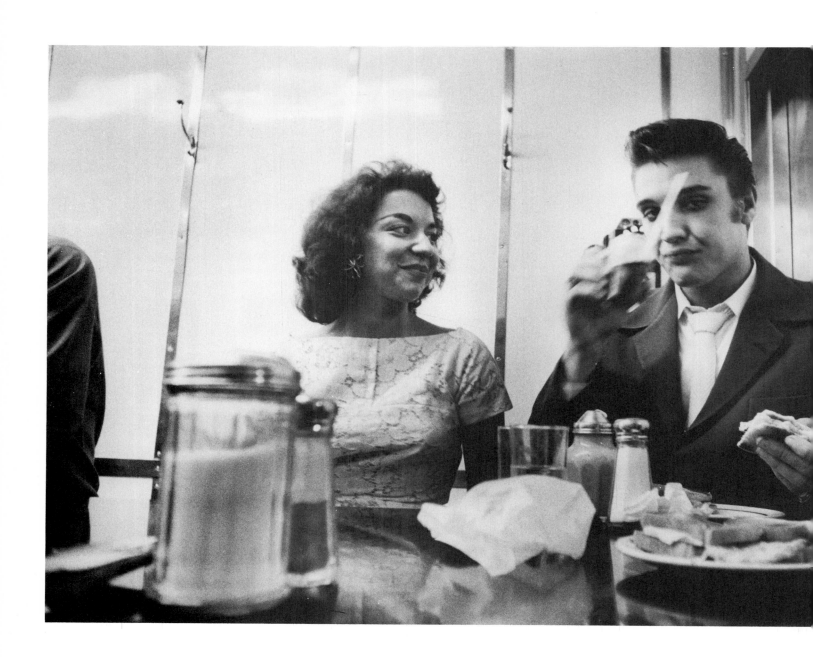

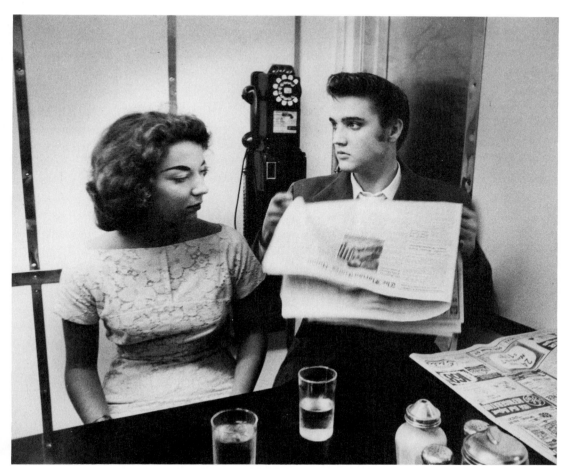

But then all the other people that were following him around all the time didn't eat anything either — the photographers took some more pictures and the rest just sort of hung around till Elvis had finished his sandwiches and quickly flicked through a newspaper. And it seemed for a little while as if his mood changed, like he was thinking of something else, and he didn't say much.

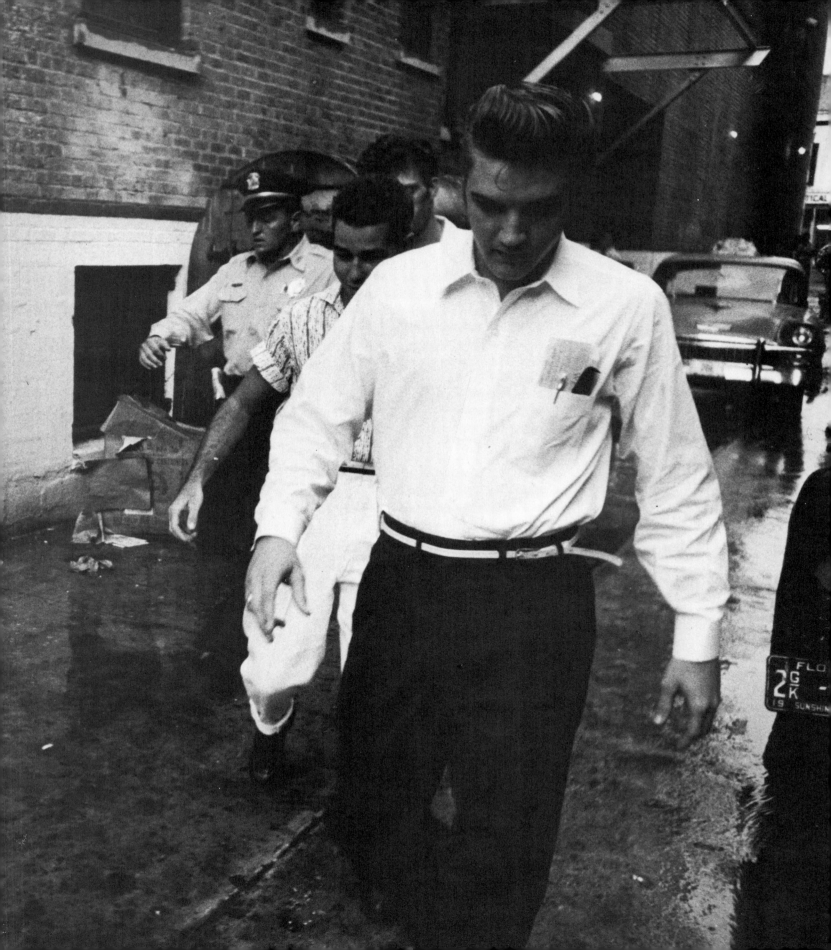

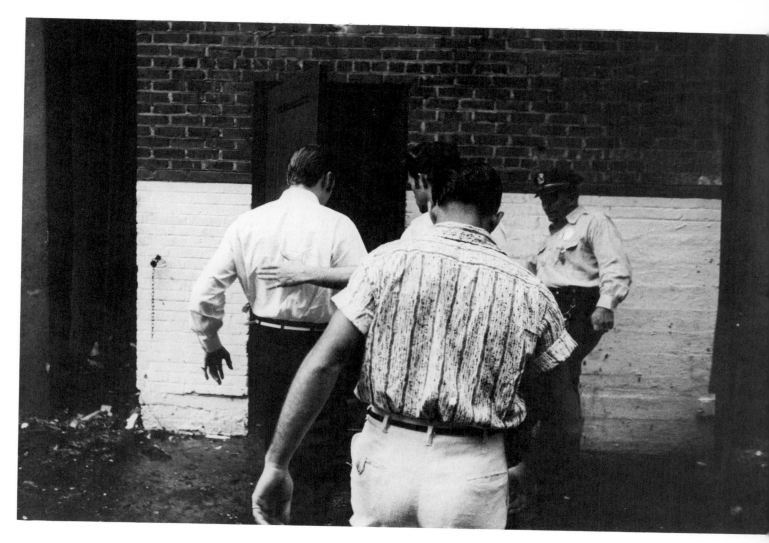

Side entrance, Florida State Theater. After a couple of cabs have come to a halt and a police car has unloaded its cargo too a group hurries to a door. Elvis is covered on all sides by men that want to make sure nothing serious happens, what with lots of fans already lined up around the corner and everybody in the entourage aware of what had happened only two days before in Orlando. They'd had plenty of cops there but suddenly with Elvis out there there'd been girls all over the stage, just runnin' wild and tearing his clothes to shreds. No wonder that with the first Jacksonville show coming up at 3.30 p.m. the pack rushes to leave the daylight behind. As soon as they're inside he asked one of the guys to get him his guitar. The other tools of his trade he carries with him in his left breast pocket — a pen for signing autographs and the comb for sculpting his hair.

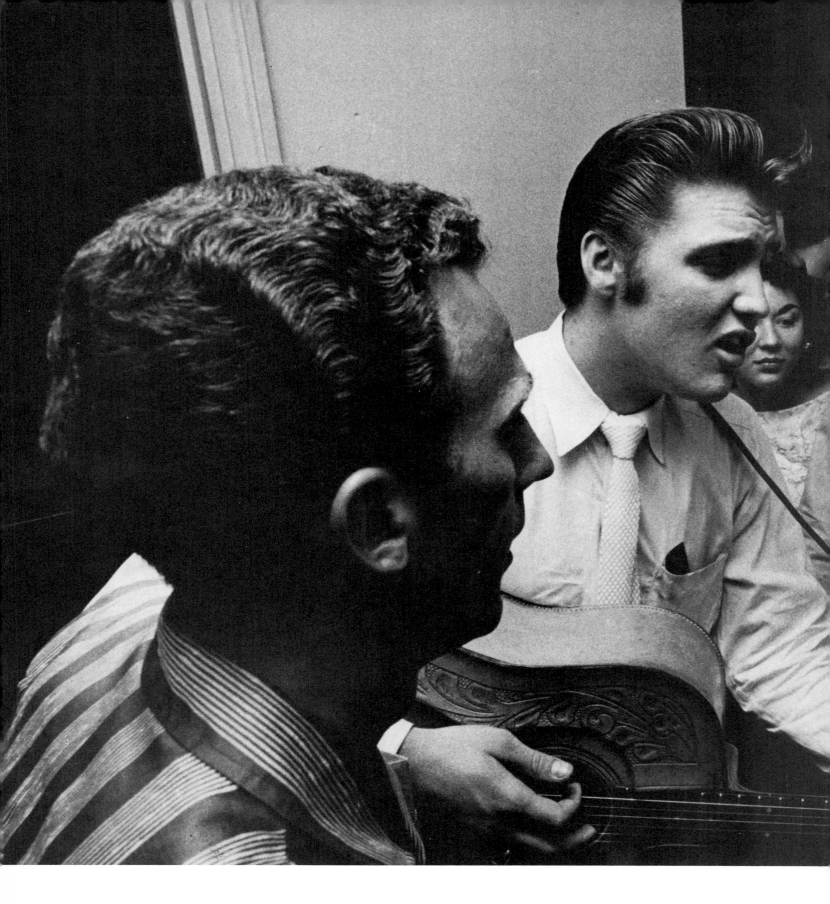

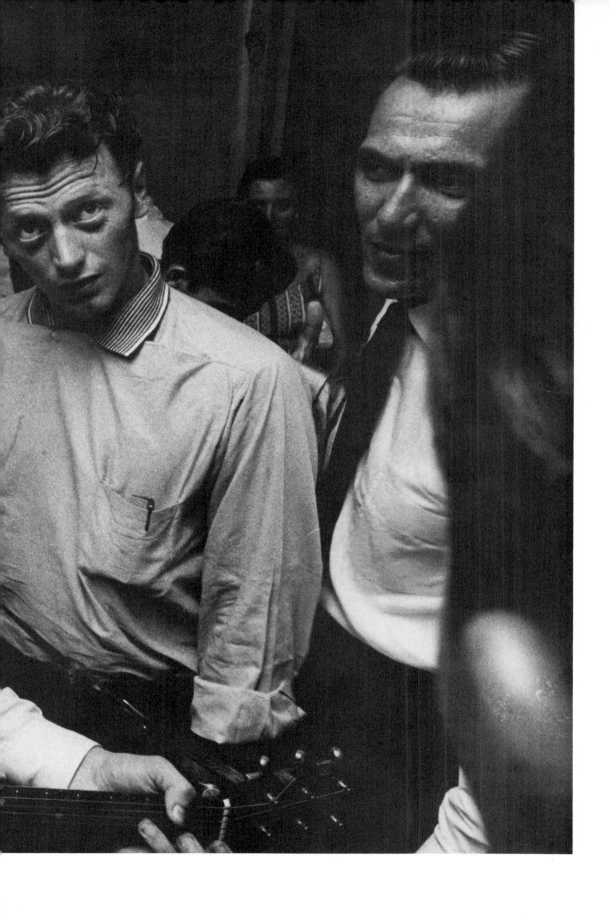

The belt buckle sits on the left too so it won't interfere with his guitar action. And once he's slung the thing on and starts warming up the vocal chords all the people around him stop talking 'cause even to old buddies like Red and Junior it's suddenly like they hear him for the first time all over again. It sounds so good they all crowd round and when he does some gospel they all join in and harmonize soft and low.

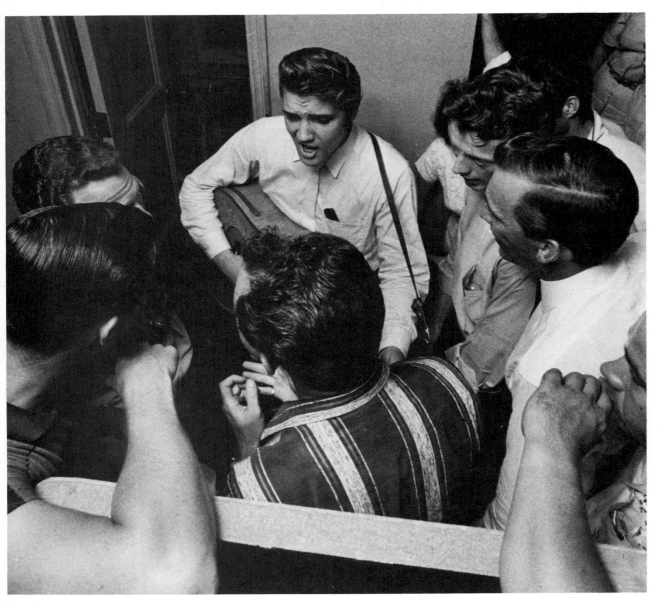

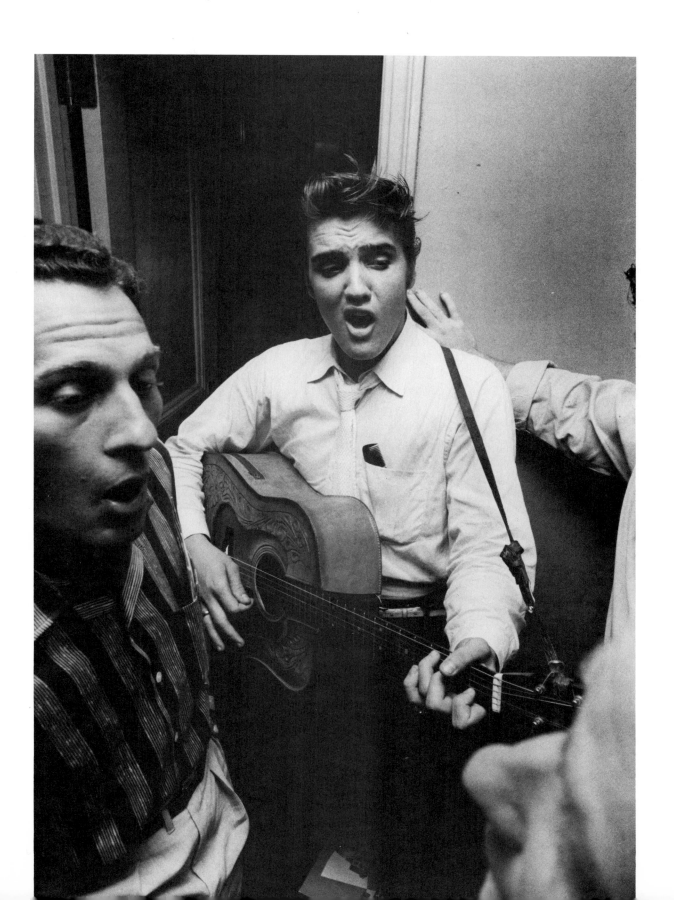

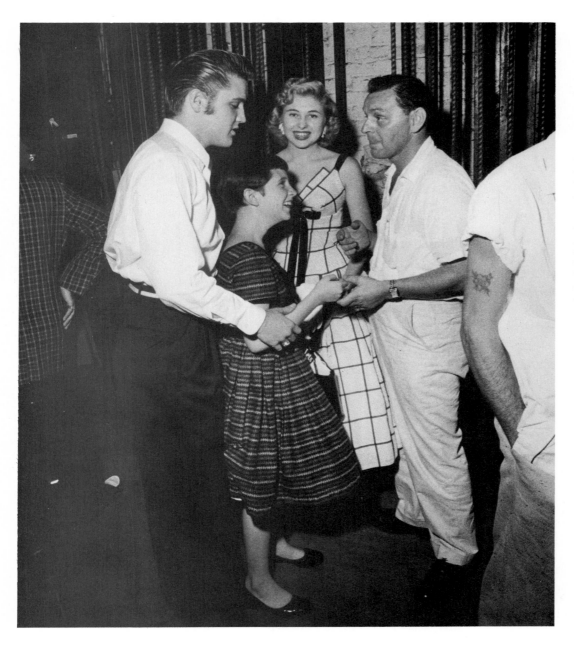

Thank you for coming.
''Ah... sir... we appreciate you comin' out here and ah, you got a wonderful daughter and ah... we sure hope you enjoy the show.'' No matter where Elvis performs at this point in his career there's always a multitude waiting in the wings eager to shake hands and be seen and photographed with him. Often parents pushing their children at him will be awkward and uncertain but more often than not their babies will be beaming.

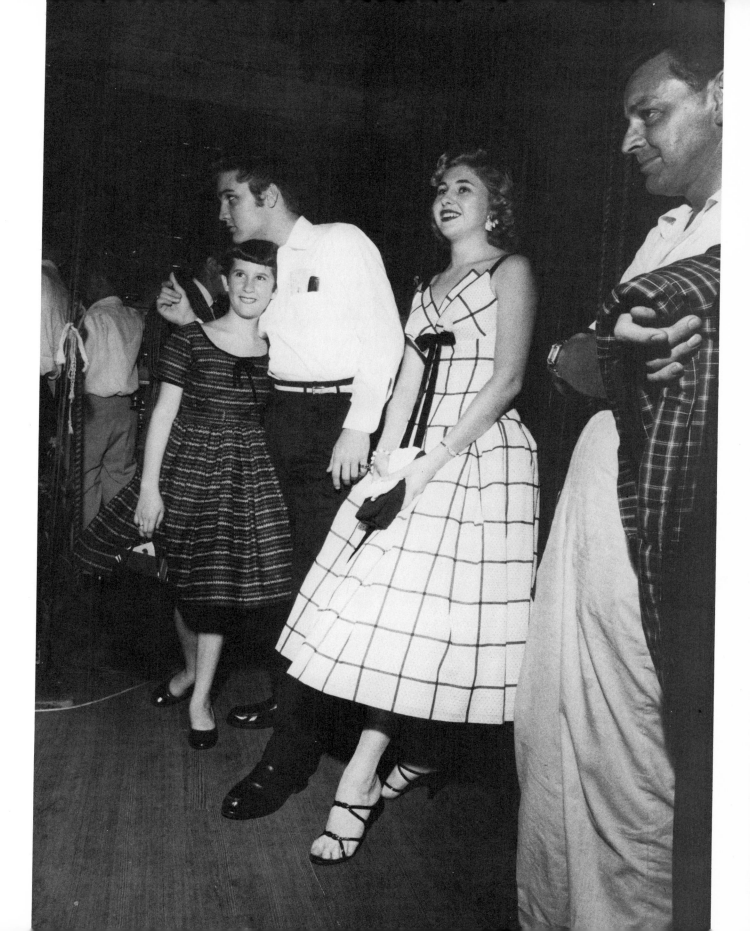

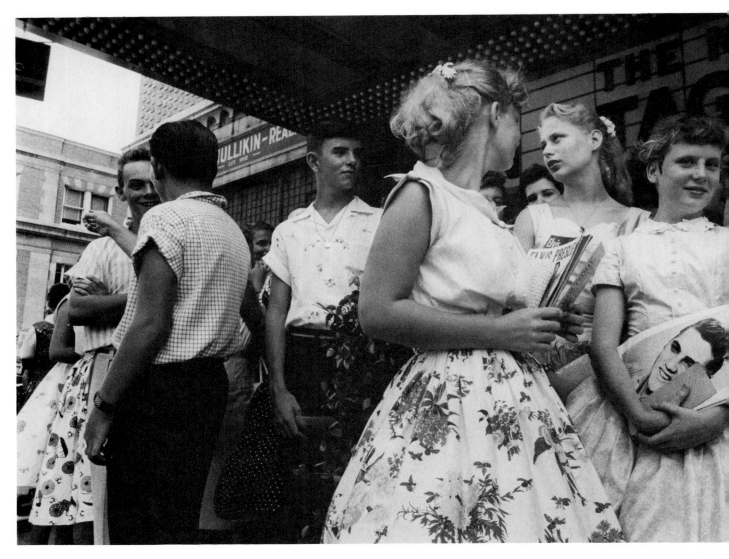

Main entrance Florida State Theater. Each of the six Jacksonville shows was sold out with the old theater packed to its capacity of 2,200. Intent on getting good seats the fans come out early, defying the heat. All they can talk about, all they can think about is inside under the protective eye of a couple of cops intent on maintaining order. No doubt they've heard some stories about how this youngster behaves himself onstage and no doubt they have their own opinion on that score but being assigned especially it's not for them to comment. The Jacksonville Police Department has decided not to take any chances because who needs bad publicity? You never know with those kids though, cause they may be quietly waiting in line before being admitted but they seem to go completely crazy when they see this fella's brand of the shakes. Better keep a close eye on them.

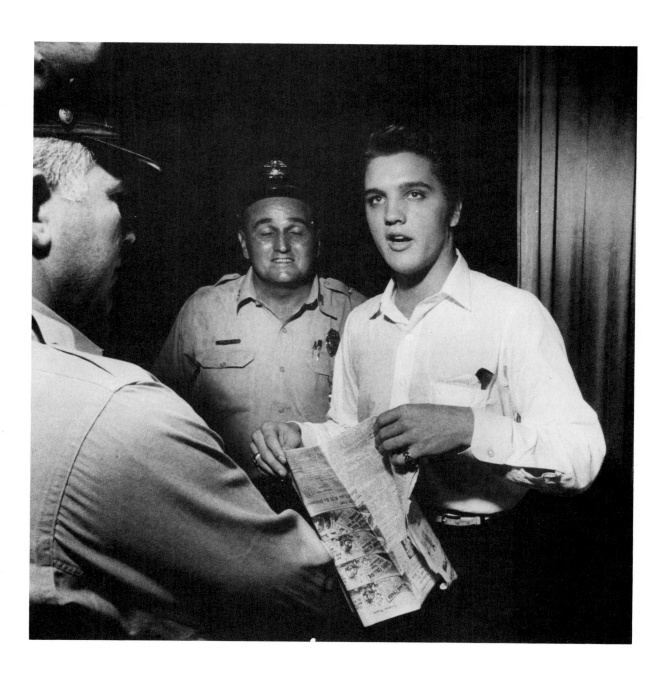

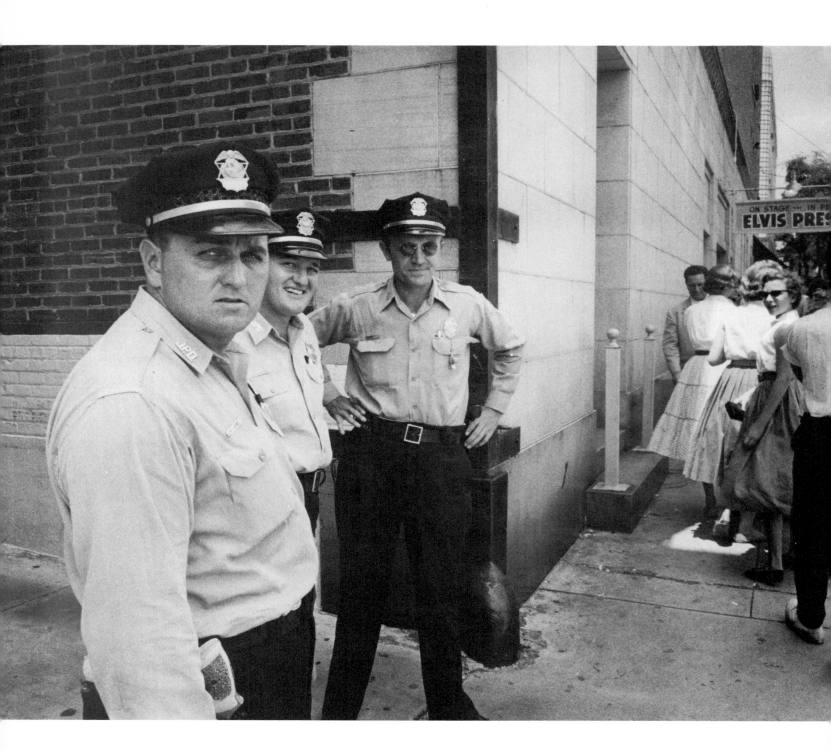

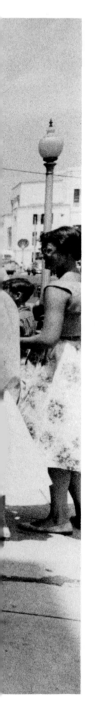

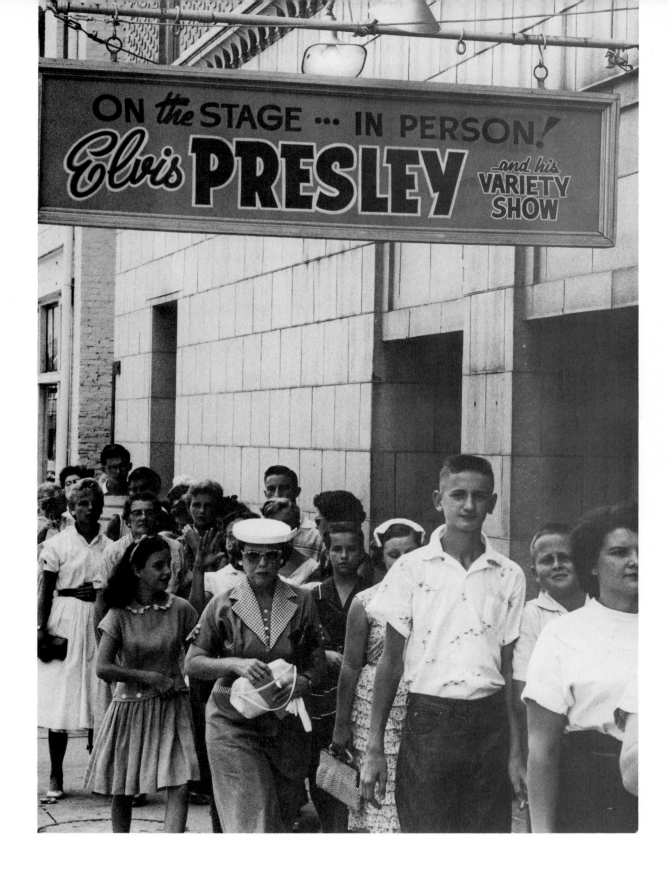

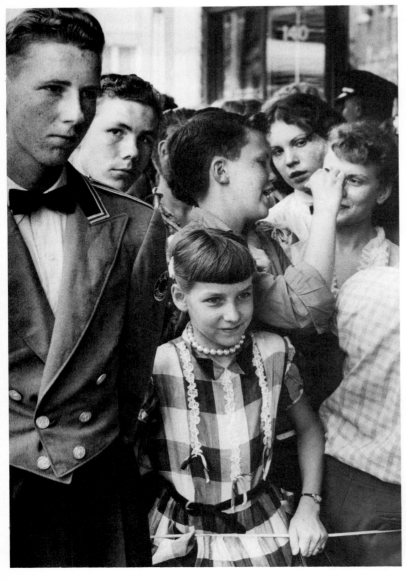

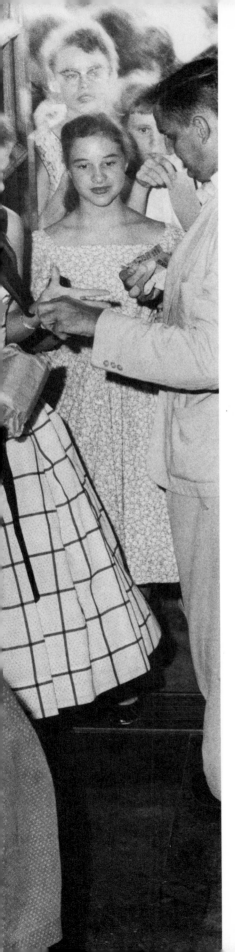

Please take your seats.
There's only a thin rope separating the ones who've waited the longest from what they've been waiting for. Then finally they take the thing away and the fans surge to the door, show their tickets and rush to their seats. They all know that it's going to be worth all the waiting and more and they charge the theater with high voltage excitement. 'Cause he's going to sing just for them and they'll be so close. He will only have to come out and wiggle a little finger and they'll surrender completely. Not that they'll be listening to the songs like they listen to them at home on the record player in the shelter of their bedrooms. No, they've come to see what he does to the songs with his body, adding substance to their most secret dreams. There's no doubt about it that this crowd like all the others Elvis faces during 1956 is ready for him.

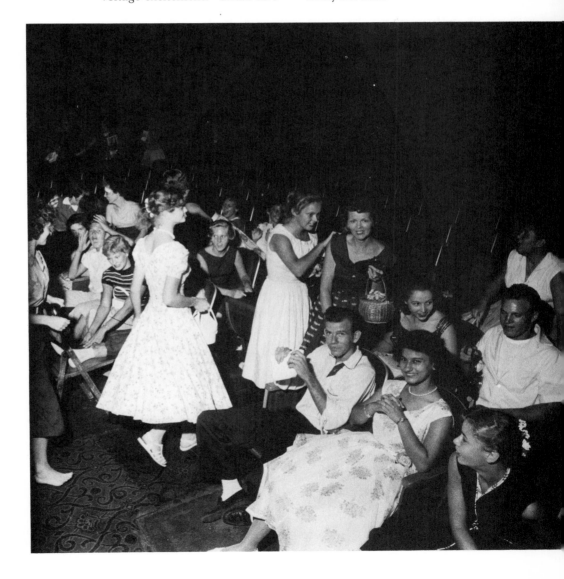

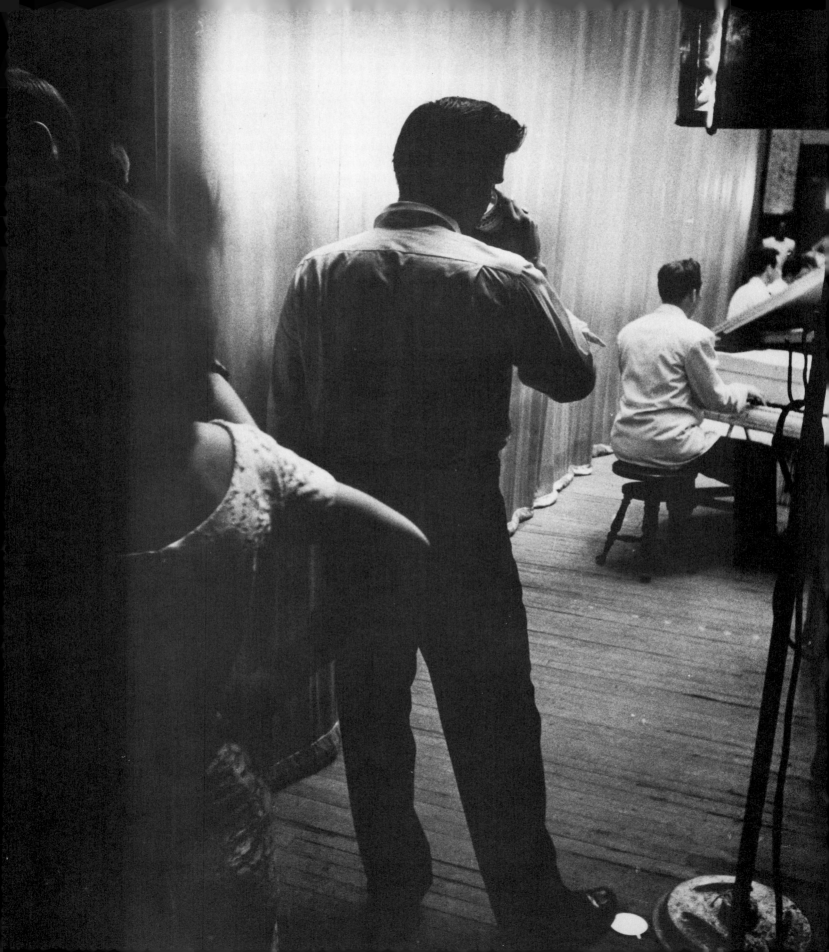

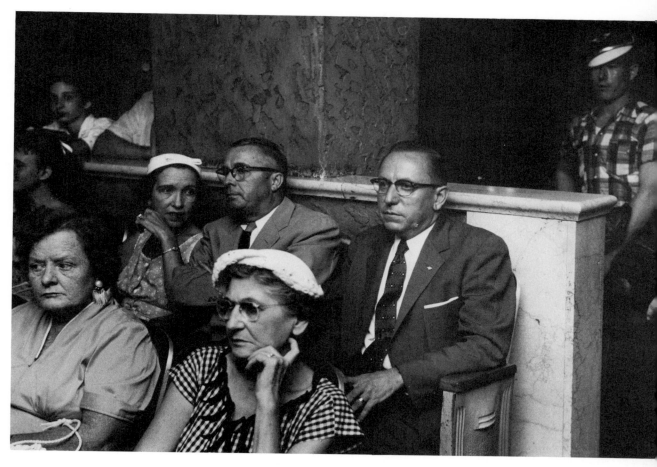

In a quite different sense some in this particular audience are ready for him too. Out there to see for themselves are Juvenile Court Judge Marion W. Gooding and some morally upright committee members. These are respectable citizens and they intend to keep Jacksonville respectable. Why, they've heard and read enough about this so called singer to know that he's a threat to their children. Even servants of the Lord have spoken out against him in no uncertain terms and haven't they as responsible parents got enough on their hands already with earning their daily bread and communism lurking everywhere? Heaven knows you don't have to be a Klan member to realize that this savage music is undermining the morals of the white youth in America.

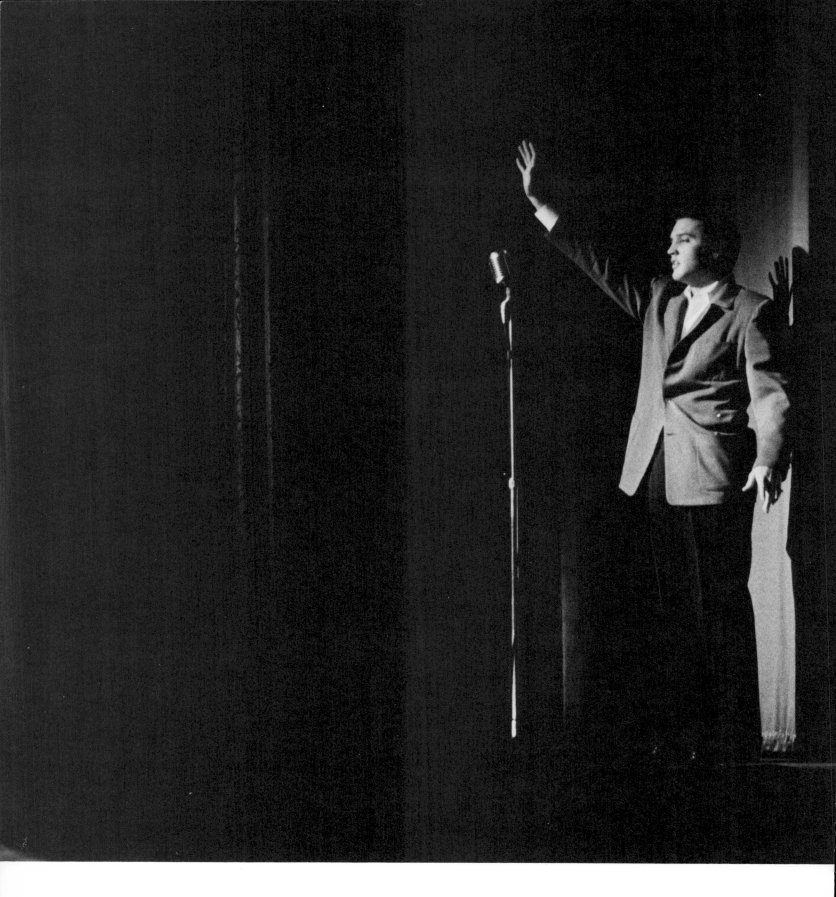

First Jacksonville Show.
The Judge and company had
never heard anything like it in
their lives before. All during the
first part of the program they
hadn't found fault with anything
that happened on stage. In fact it
had all been clean and decent, if
somewhat spun out. The
audience had politely applauded
the succession of acts and had
only become noisier when three
plait-jacketed men had come out
and sang harmony. But then
when the star of the show walked
on stage the girls started
screaming so loud that it made
the judge sit straight in his seat
with a look of alarm on his face.
And then when Elvis waved at
them they shrieked louder still.

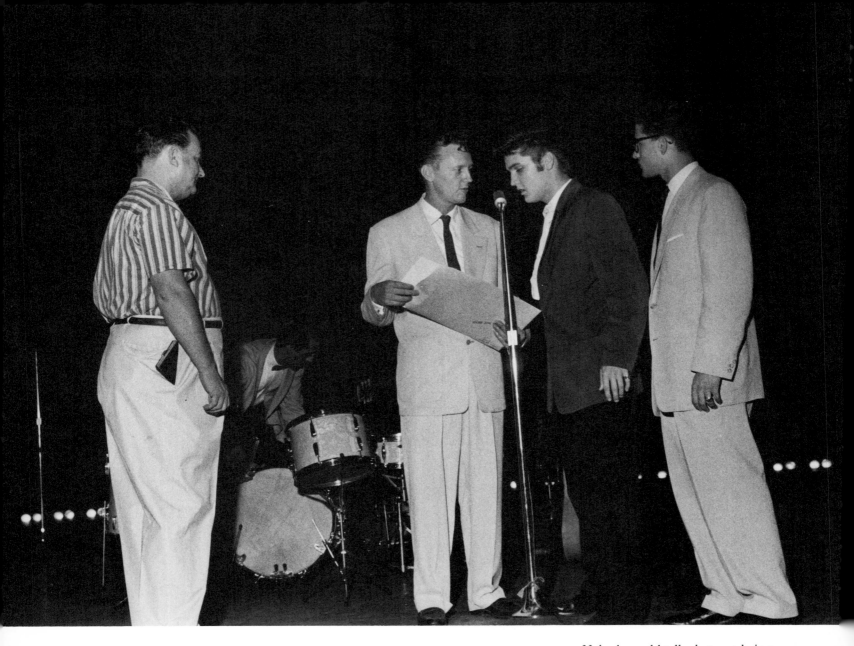

Nobody could tell what was being
said when some officials
presented him with an award and
the judge only caught the word
'friends' before he picked up his
guitar, braced his legs and
grinned that grin.

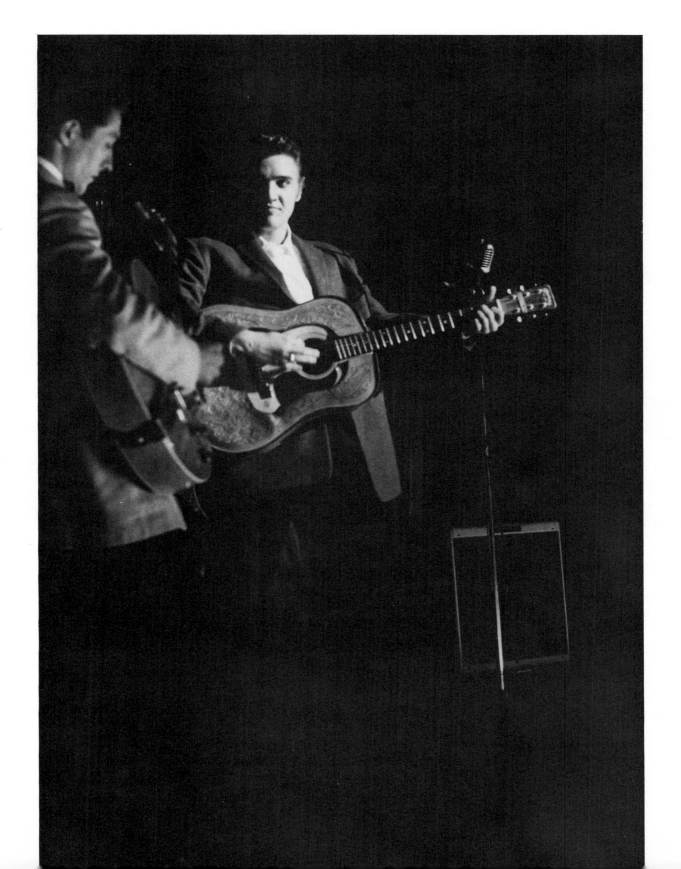

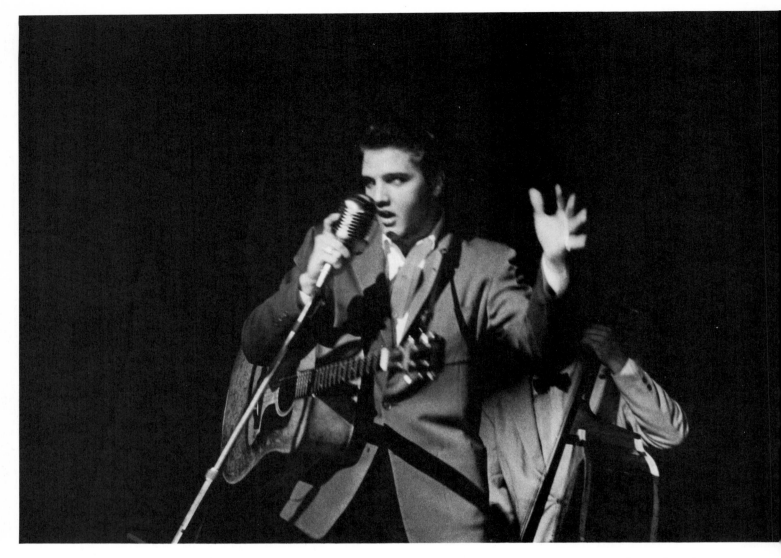

...to cry there in the gloom...
Anonymous immortality for the guy who at the end of 1955 committed suicide in the Jacksonville area and left a note saying 'I walk a lonely street.' On reading an account of that event in a local newspaper Mae Boren Axton hit upon an idea for a song that when it was finished bore the title 'Heartbreak Hotel.'
Certainly writing a country song on the theme of loneliness was about as original as writing one about love, but when the composition ended up at Elvis' first major recording session for RCA on the 10th of January, 1956, he somehow managed to transform a straightforward country lament into an anthem of loneliness. Only seven months later all he has to do at the beginning of each performance is to strum his guitar once and sing the first word for all the girls out there in the audience to understand all about his misery and gloom and to yearn to somehow help to ease his pain.

But he changes faster than the sky when a hurricane is coming and lets them know with a crooked smile that he really ain't about to walk that lonely street just yet. And as the squeals hit a new high he stalks the stage, manhandles the microphone and drives their emotions harder than they've ever been driven before.

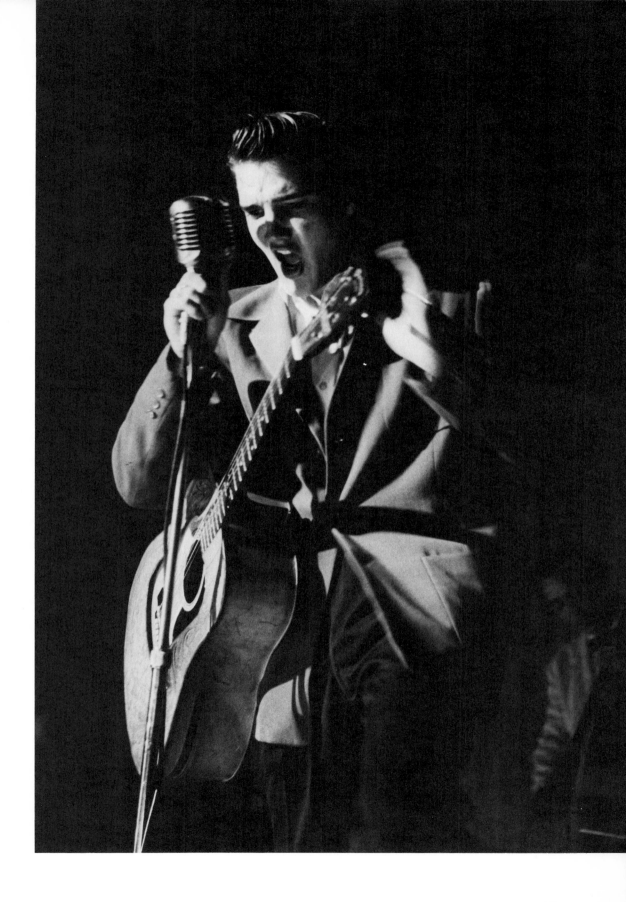

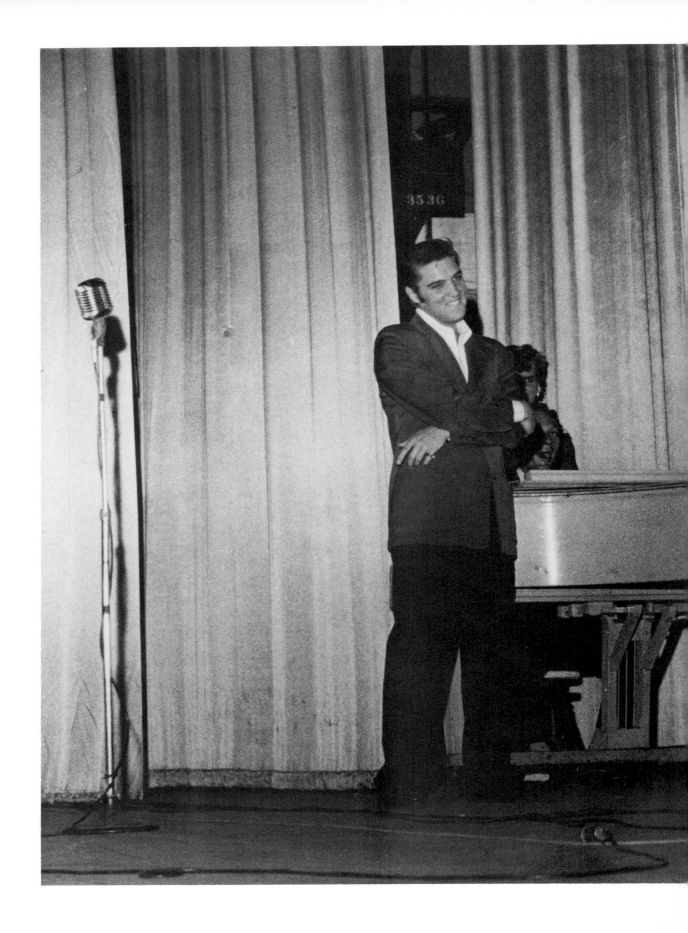

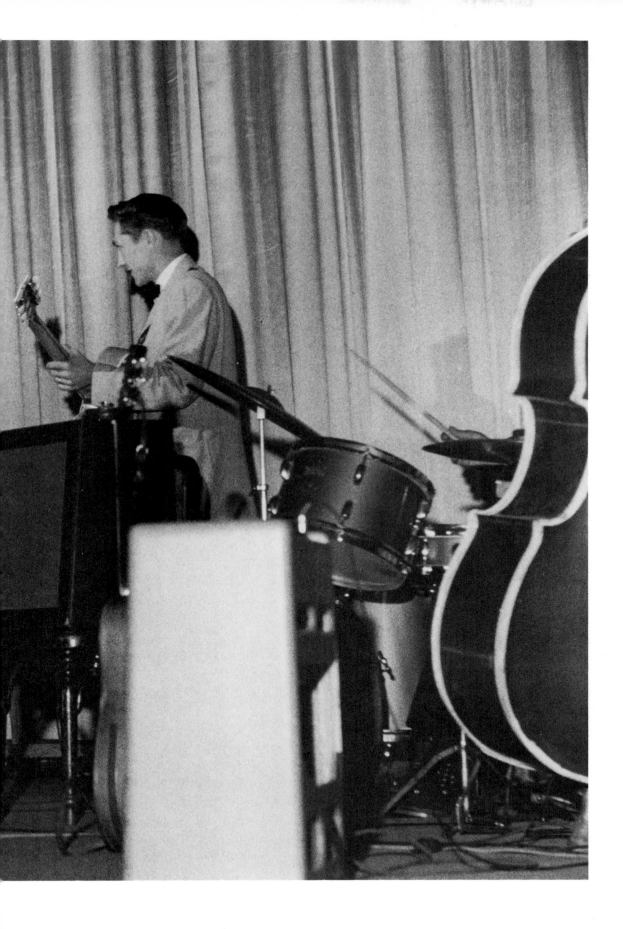

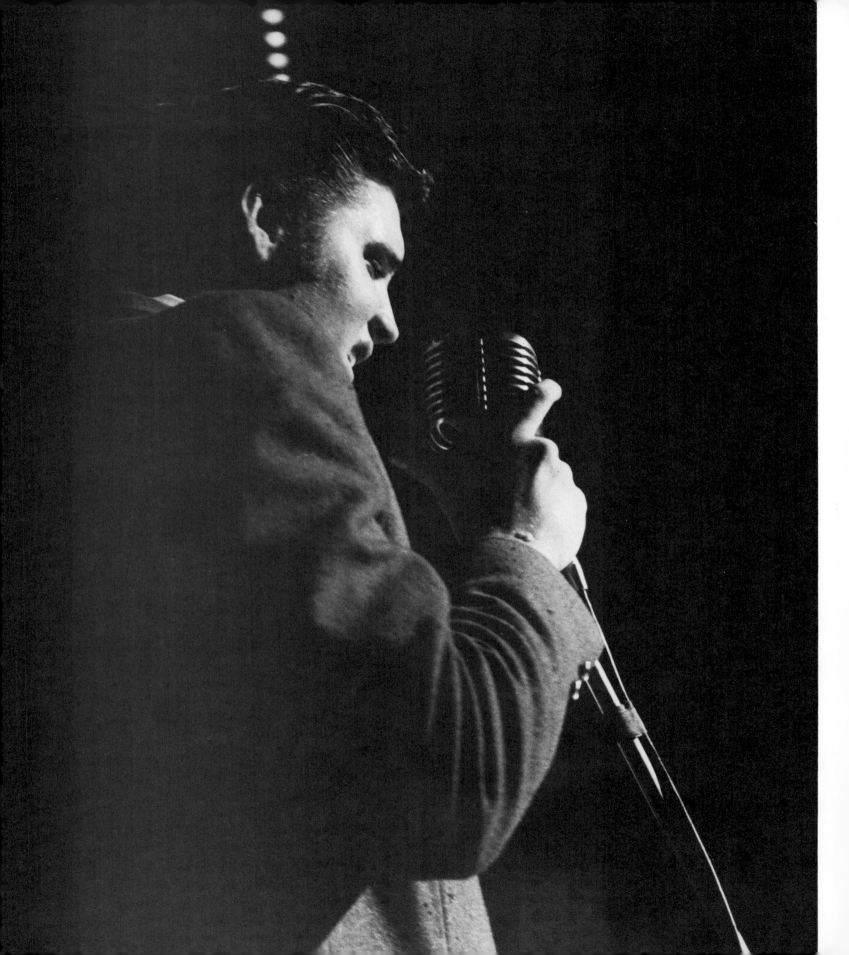

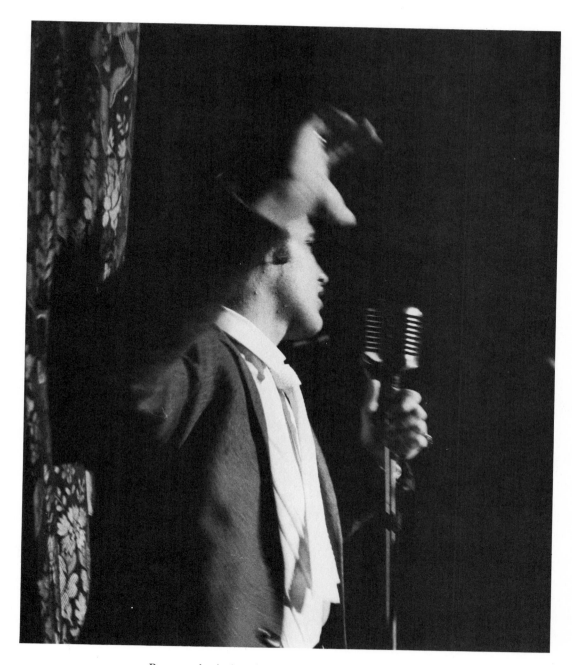

By now the judge sits frozen stiff with outrage and bewilderment but there's more to come with Elvis bent on giving the crowd their money's worth. He sings he wants to play house with them and by now he's gotten rid of the guitar and his hand whips the air and his left leg runs its own riot and then he crouches. Now there are girls with tears coming down their cheeks as they laugh, weep, clutch their souvenir programs or stretch out a feeble hand to him. Reaching out.

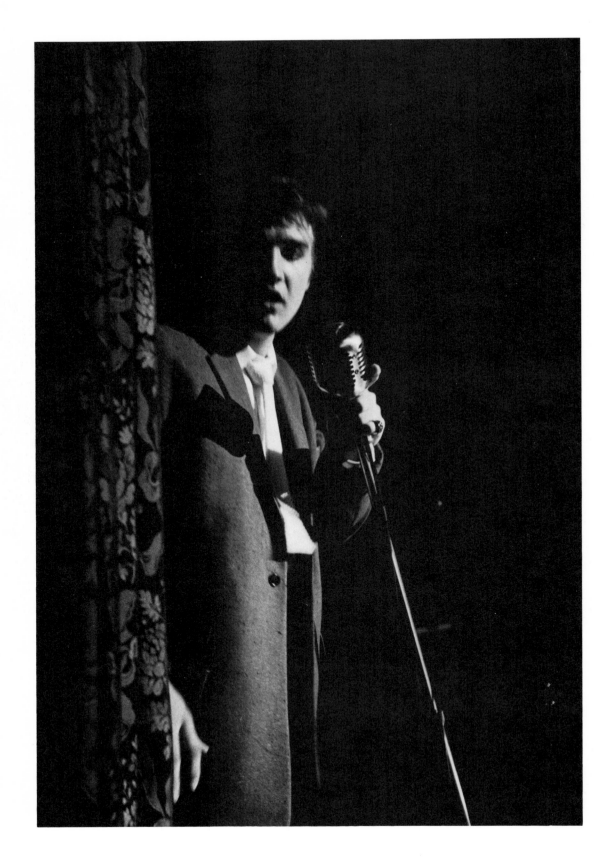

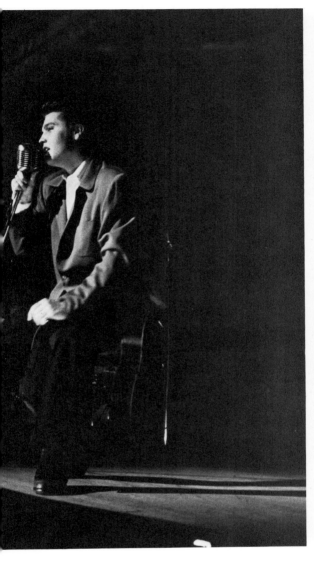

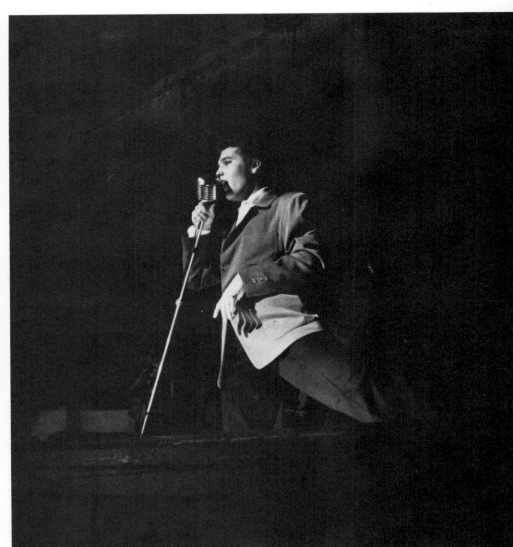

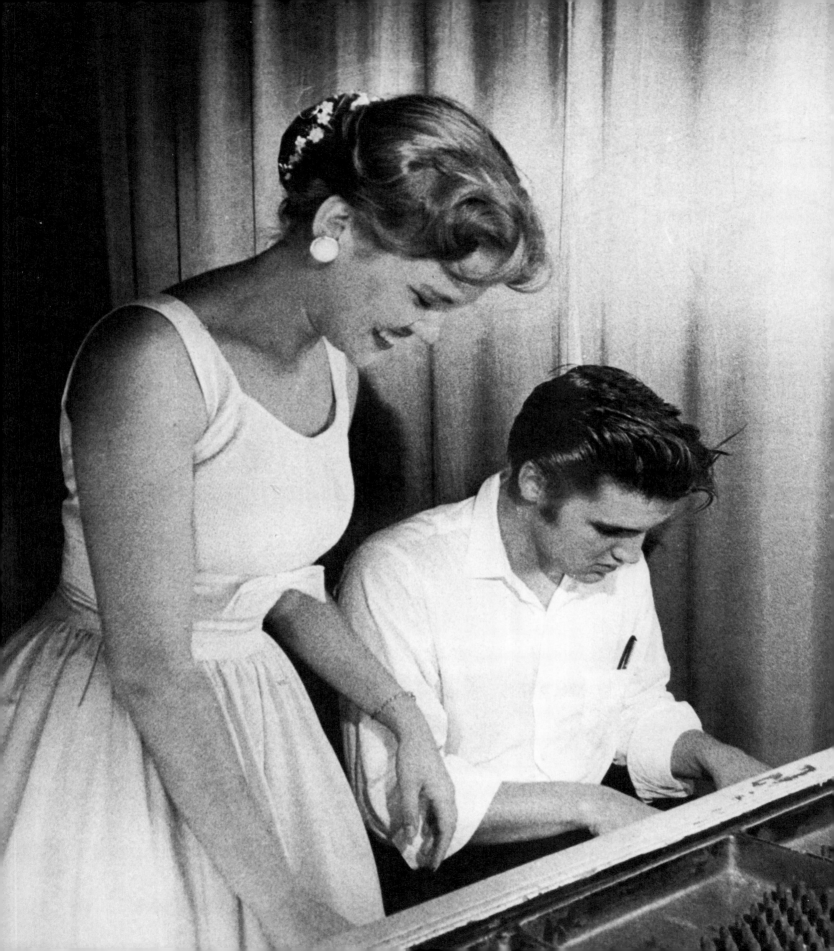

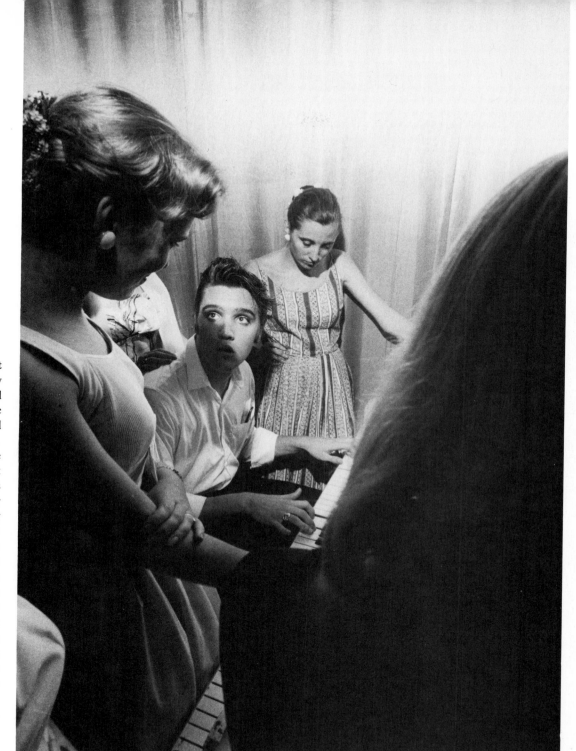

Waiting for the next show. Now the first show has been taken care of and the two evening shows are set to begin at 7:30 and 9:30 p.m. respectively. With the rest of the program taking up about one and a half hours this means that Elvis will for the first evening performance not be required to come out at around 9 p.m. Even with a long wait ahead of him music is never far. Amidst all the bustle of a theater preparing for the next performance, with shouts of stage hands and the nervous twitter of a group of girls anxious to get as close to him as possible, Elvis lets the piano do its own talking in gospel like tones.

Then the King's dinner is announced to be laid out in becoming style. Elvis takes his dinner from a large crate in a room that is far too small to accommodate all those interested in being granted an audience. Having a quick look for himself 'round the corner is D.J. Fontana who these days doesn't see much more of Elvis than he sees of him on stage.

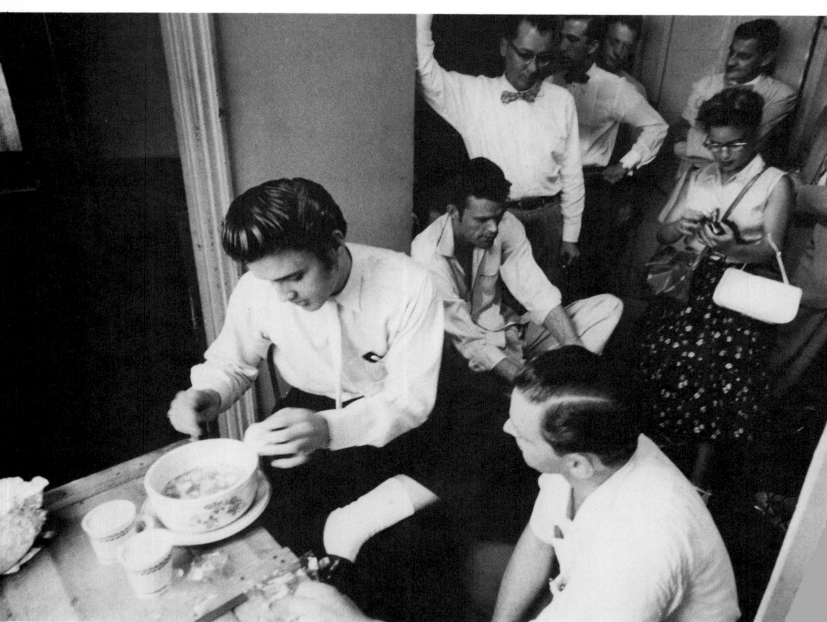

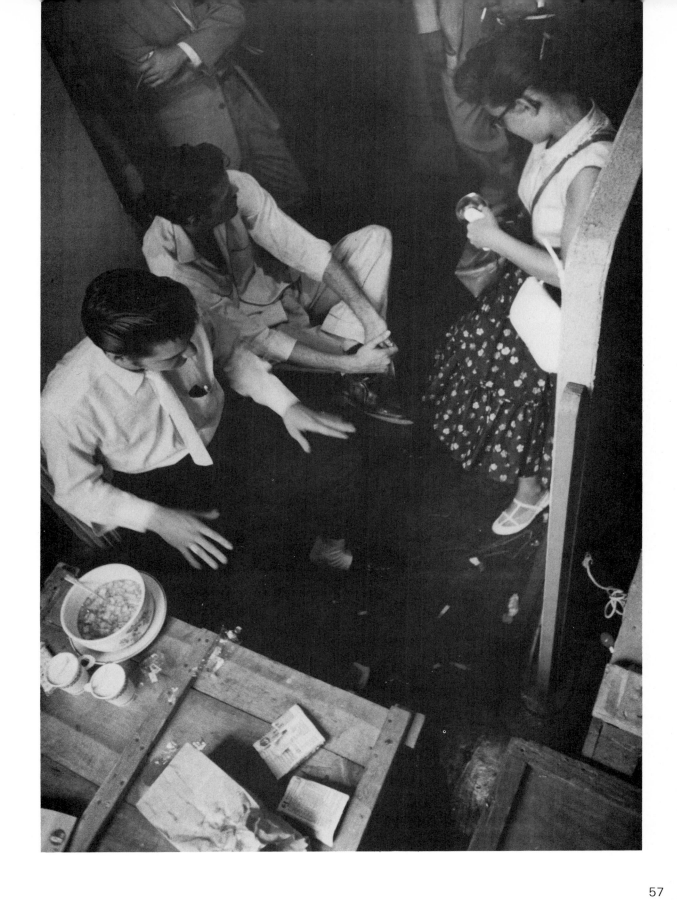

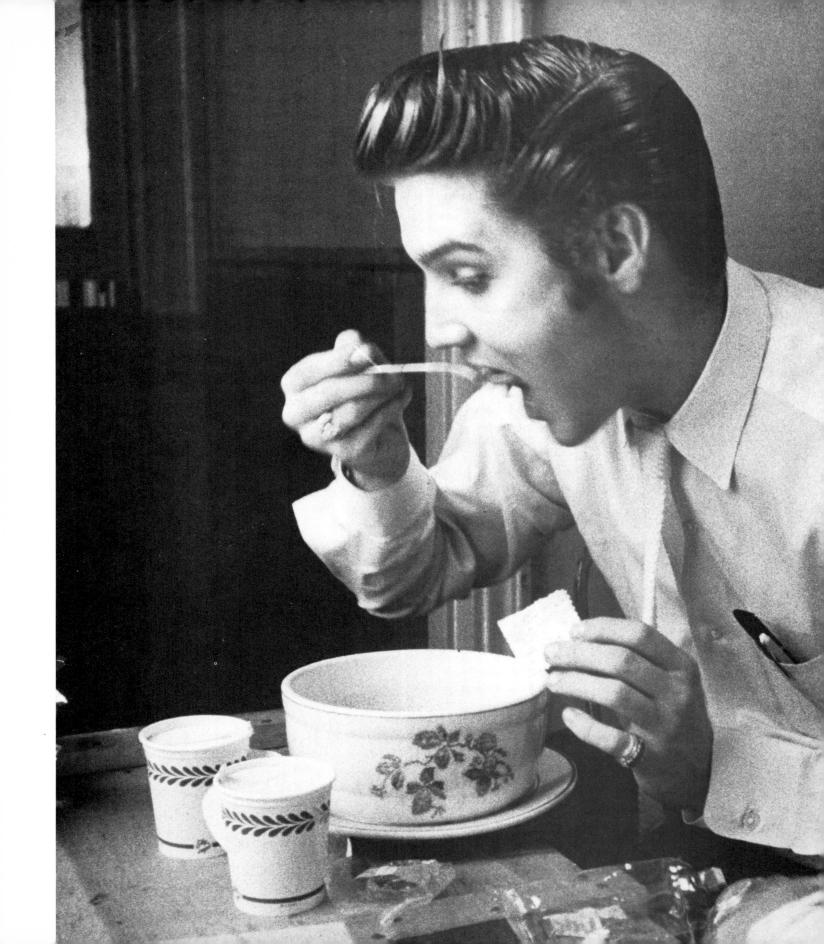

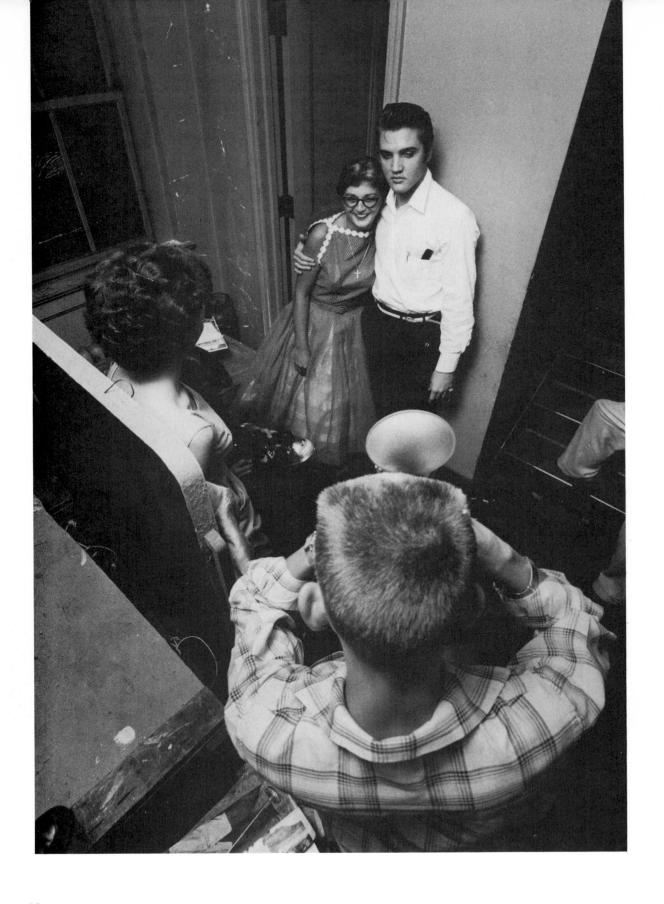

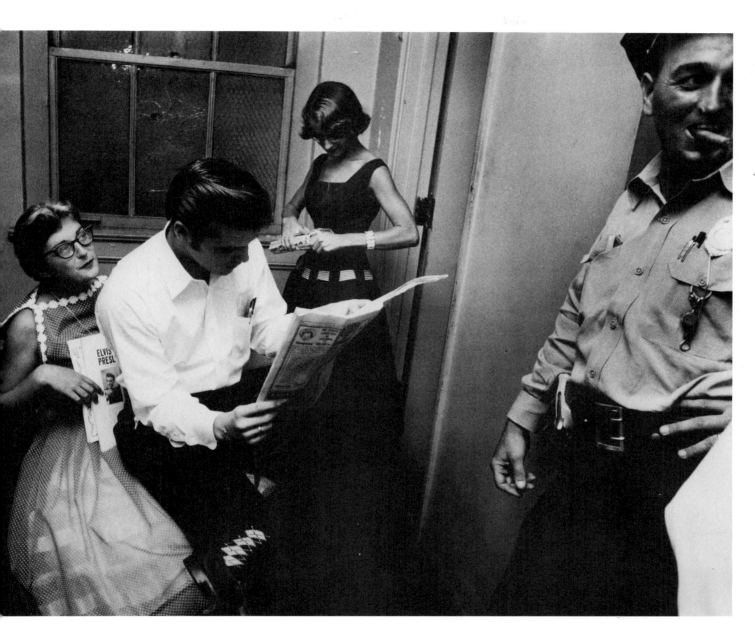

She knows a woman's place. After dinner some more flash bulbs are popped as Elvis obligingly poses with yet more female fans. And then he does what lots of other men do after dinner — sit down and read an evening paper. This time the King perches on an unusual throne and one wonders if she wouldn't rather be talking to him. However, this is as close as she gets.

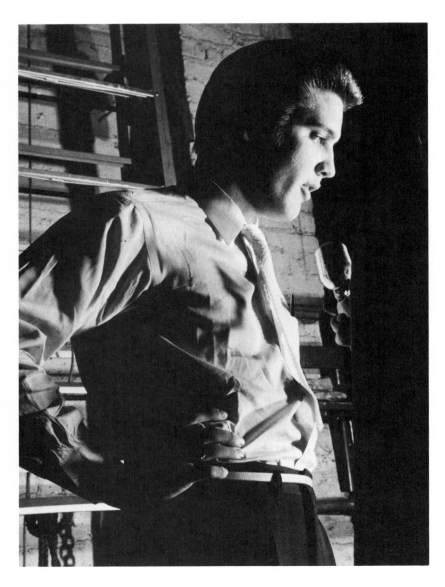

First evening performance.
"Well I'd like to just take a
minute of your time, I know
you're in a hurry," the
interviewer from a local radio
station says and holds out a
microphone. Elvis doesn't have
to say much, for like with most of
the other radio interviews the
other guy does most of the
talking. This one's already been
outside and taped some
interviews with fans, but boy
they'd been so excited that he'd
had to do nearly all of the
talking. The thing that struck
him though was their loyalty and
he asks Elvis about this. "Yes,
sir, people have been loyal to me
and I feel the same way as they
do about me, I feel about them…
uh… yea."

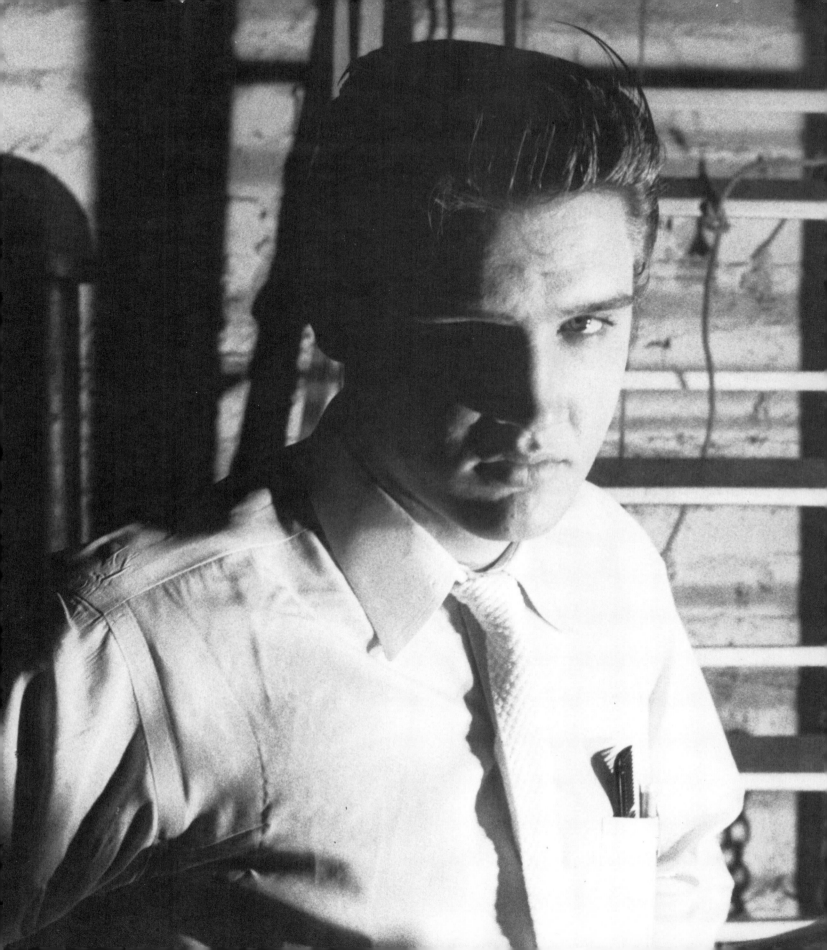

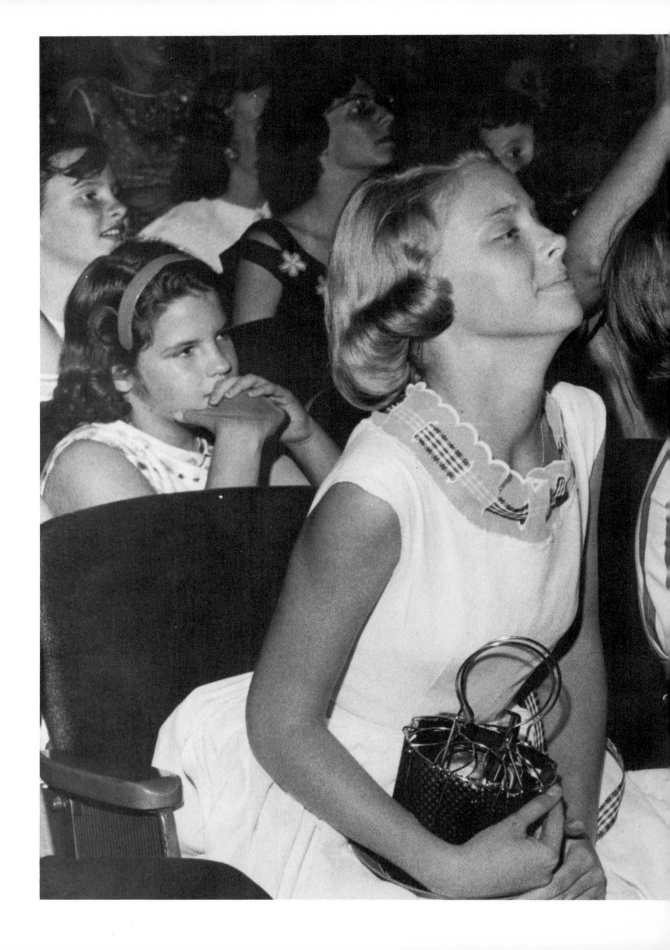

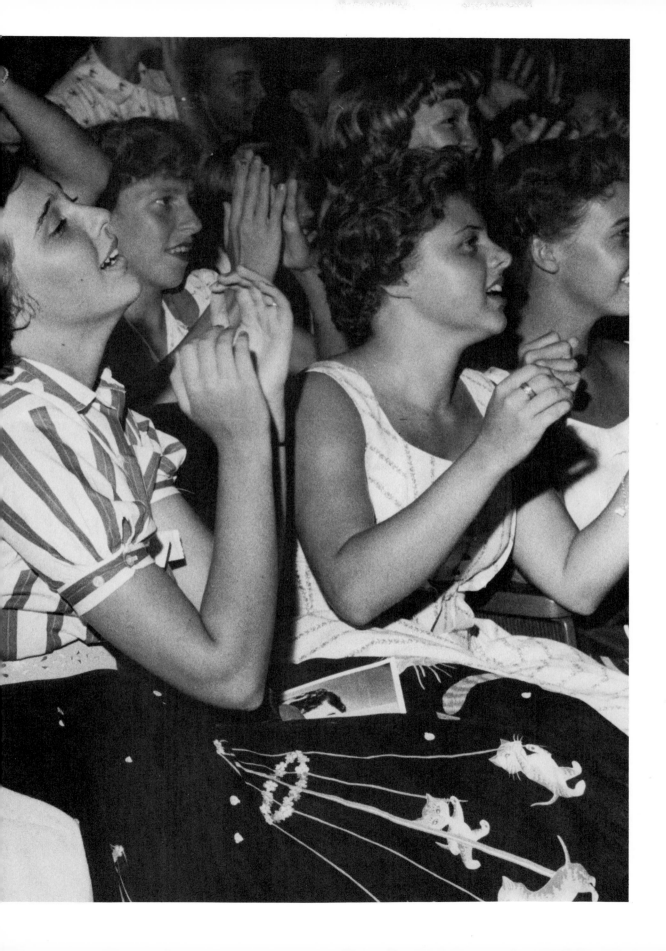

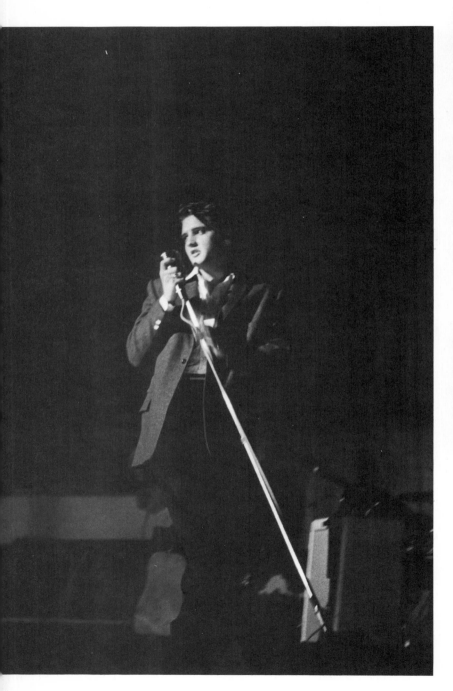

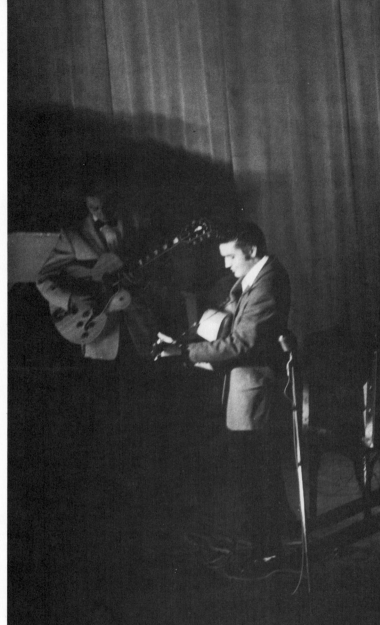

All my trials, Lord.
There's only three times on this
Friday that Elvis is not bothered
by anyone and can be his own
man completely. That's when
he's on stage and surrounded by
professionals like Scotty Moore,
Bill Black and D.J. Fontana.

66

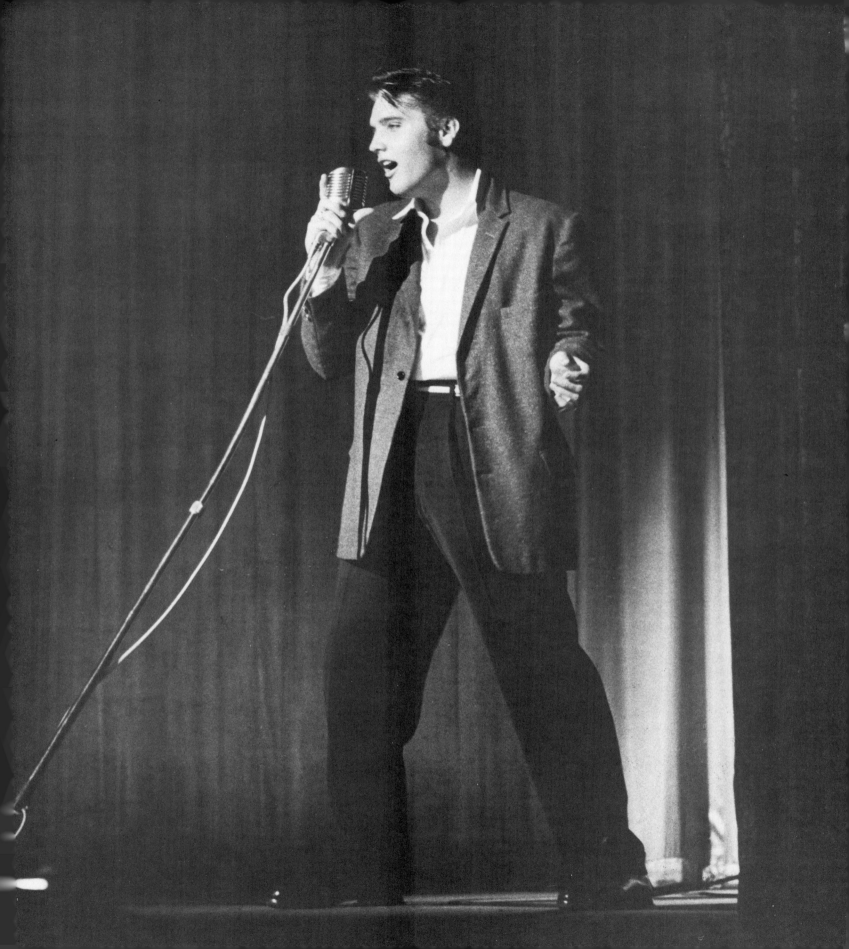

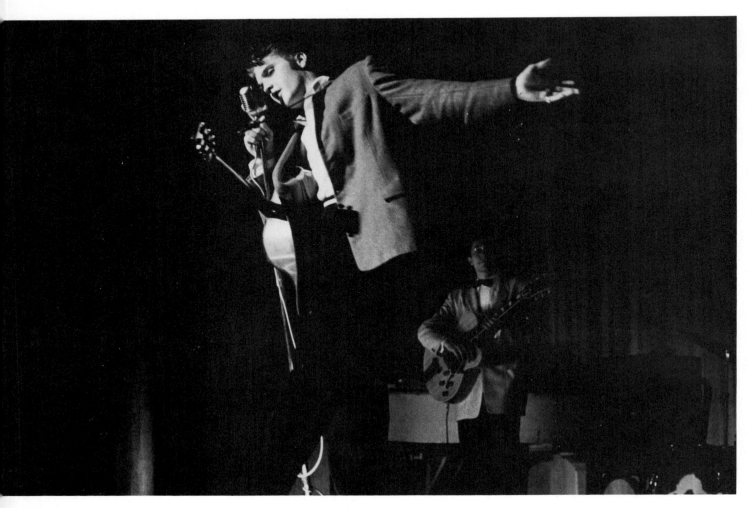

Now of course they and the Jordanaires too know their parts in each of the total of seven songs they'll be doing. And the Lord knows they've done 'em often enough before. But the main problem that they've had ever since he scored his first big hit is simply hearing themselves. Now Scotty's amp is cranked right up but there is no way of overcoming the screaming every time Elvis pulls another one of his tricks. And he may be practically eating the mike and they'll still not hear a word he's singing when he's got them all eating out of the palm of his hand. It is this or rather the means by which he gets them that far that worries the judge no end.

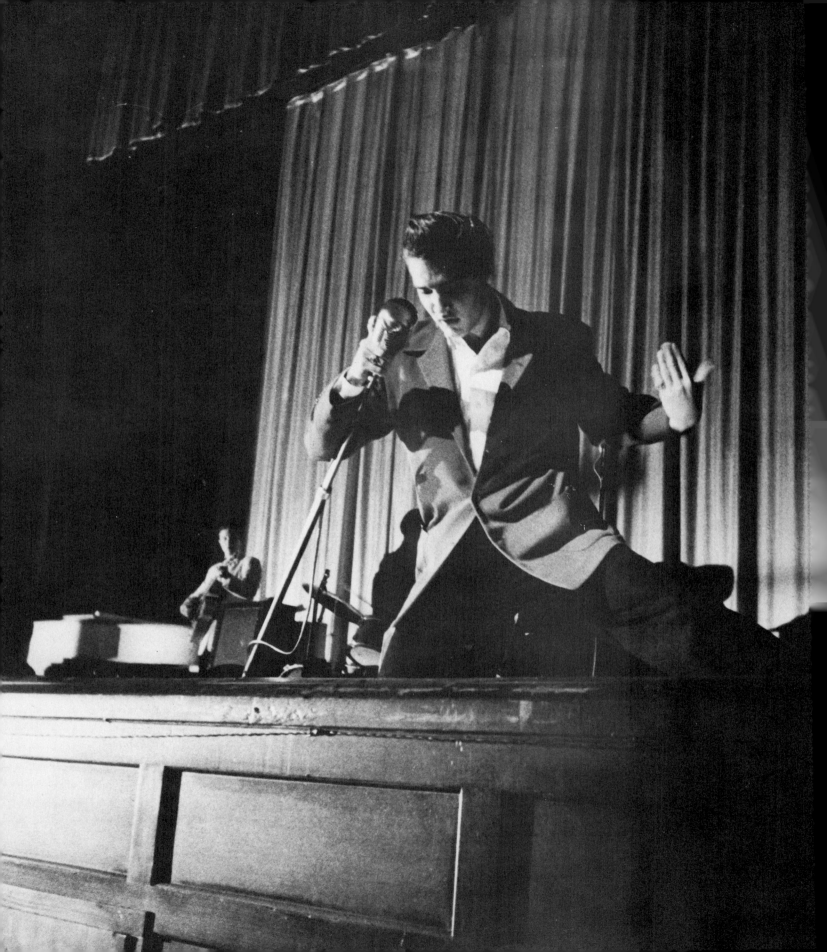

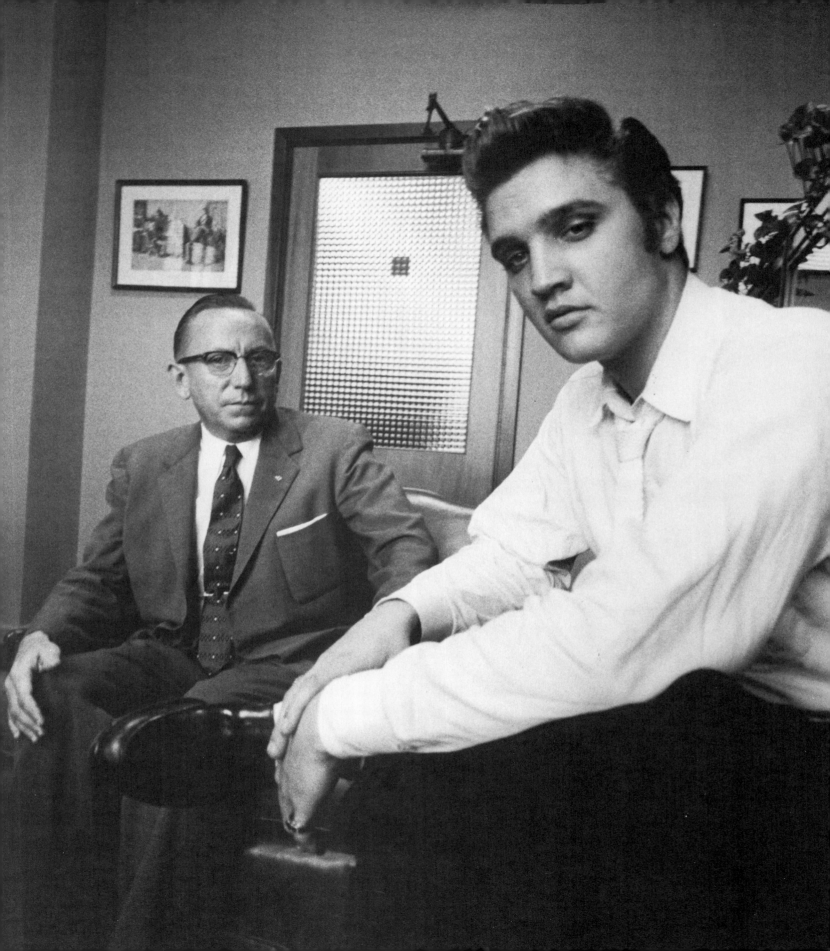

To make sure no misunderstanding is possible Elvis is summoned to listen to what judge Gooding has to say on the subject. He makes no bones about it that he doesn't like what he's seen during the first show and then after rambling on about maintaining order and such tells Elvis to tone down his act for the other five Jacksonville shows or else. Elvis complies, sort of, but he never forgets.

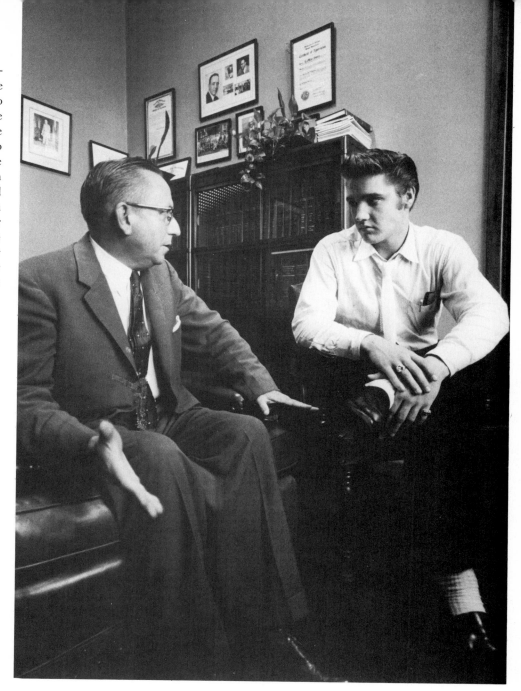

And it was all for me.
They hadn't thought of things
like the generation gap and youth
culture while they were being
invented by Elvis and his fans.
His stately cool was instinctively
understood by all that didn't
need to articulate their feelings
and in most cases weren't
expected to by their parents
anyway. Just asking questions
about it was already a sign that
you were not a part of this
perfect cultural symbiosis. I
mean what more did you need to
know after coming under the
spell of his voice than the color of
his eyes and his hair and what
kind of clothes he wears.

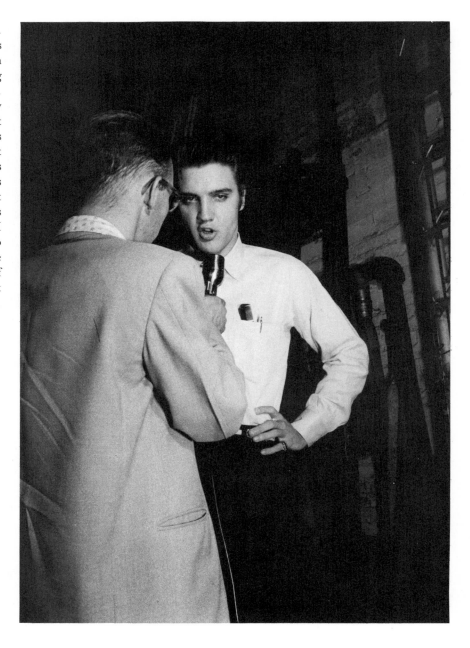

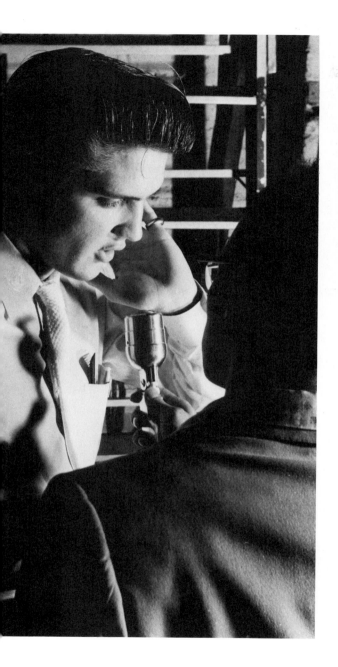

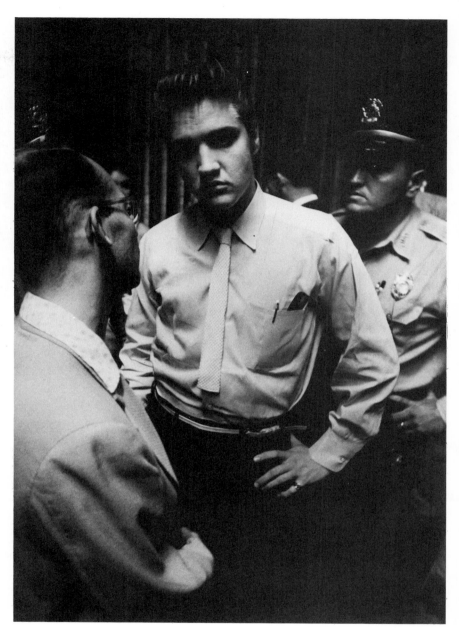

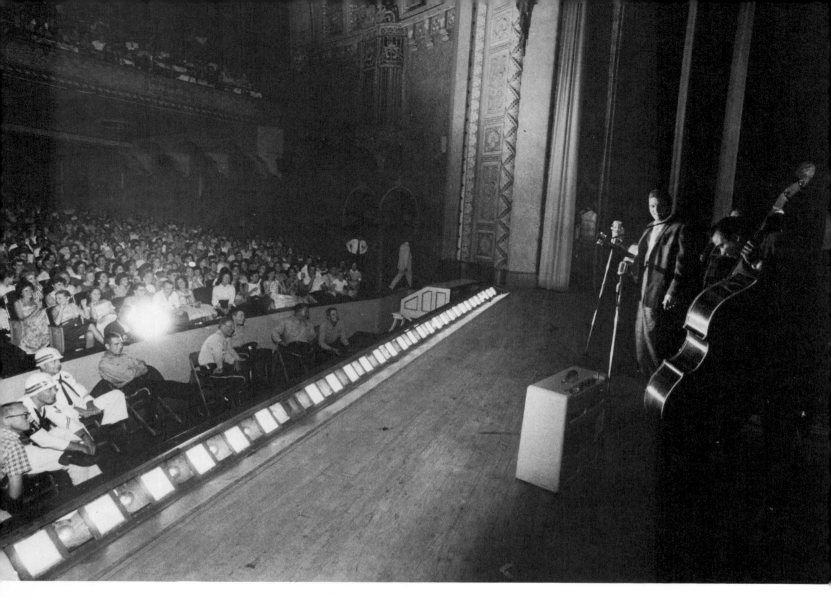

So when he steps out into the glare of the stage and footlights girls gasp when they see his bright green jacket, black trousers and loafers, white shirt and white knitted tie. Little do they know that this is all Elvis will be wearing these three days, with only an occasional change of shirt or trousers in between shows. Even if they'd known they still wouldn't have cared and should you've asked them what they liked about Elvis the girls would've perhaps given you a strange look, would've shrugged their shoulders and said: ''Ooh I don't know, I just like it all I guess!'' He'd give 'em all too, until after barely thirty minutes of him onstage they would all feel exhausted in a way they'd never experienced before. And yet they could never get enough.

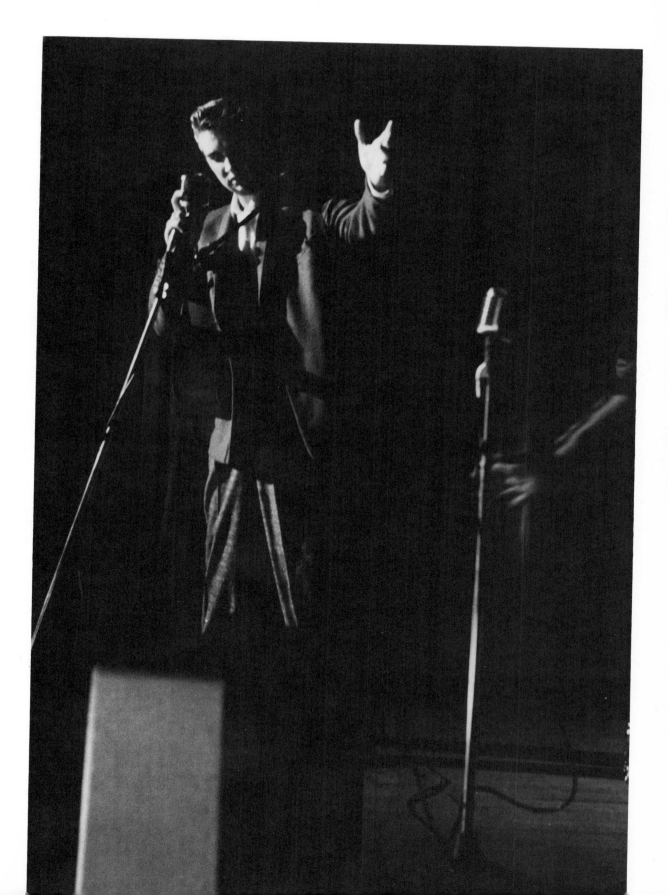

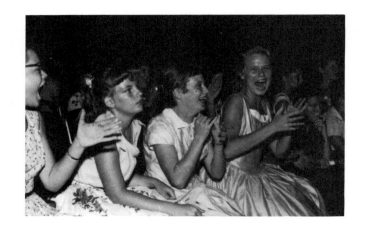

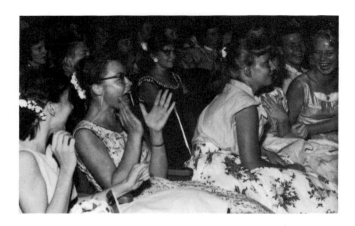

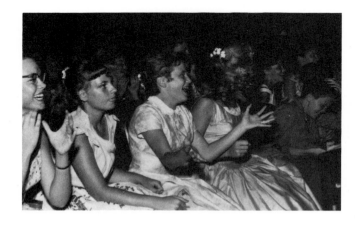

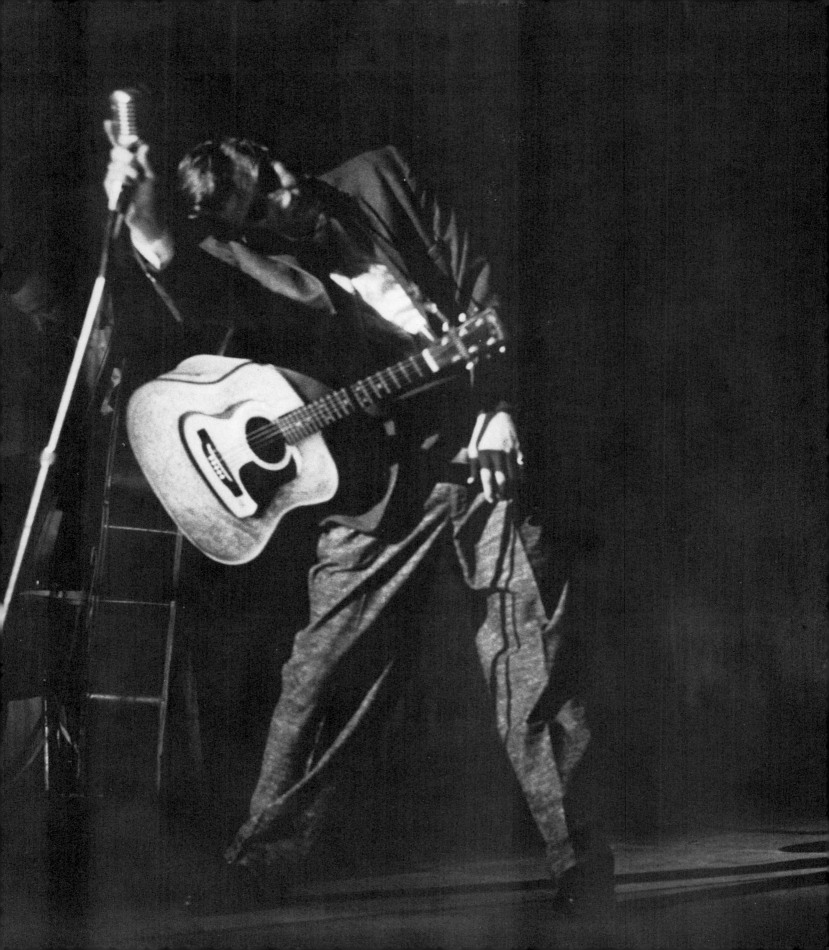

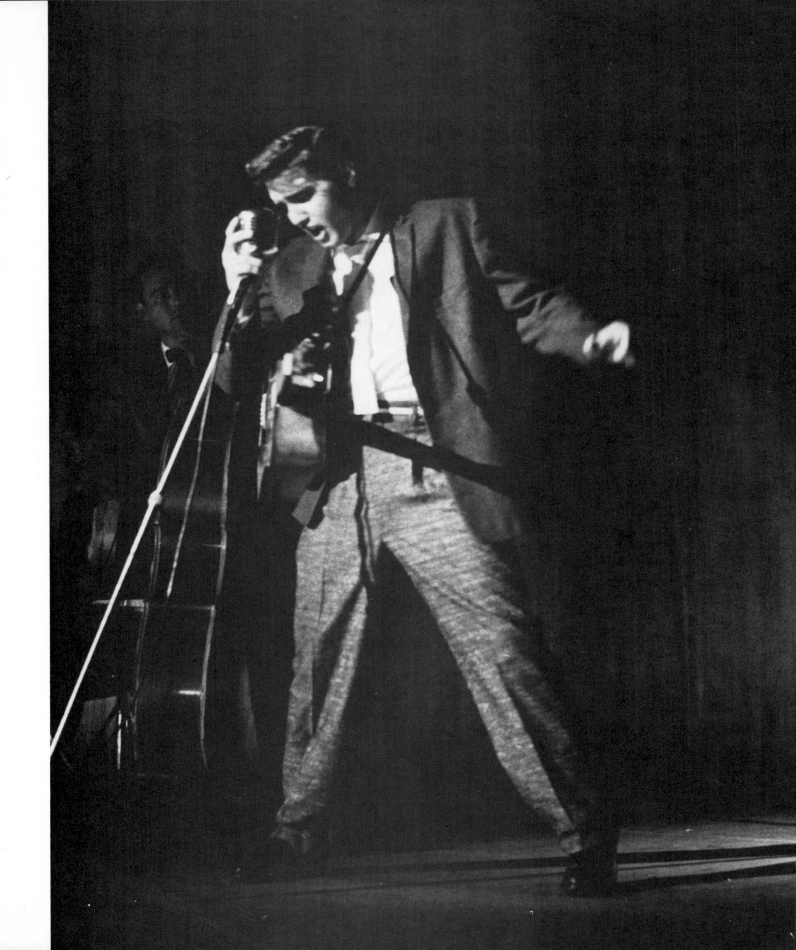

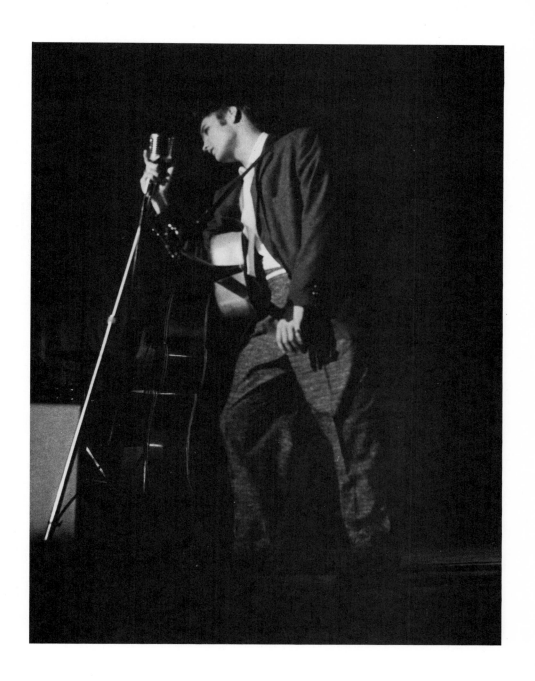

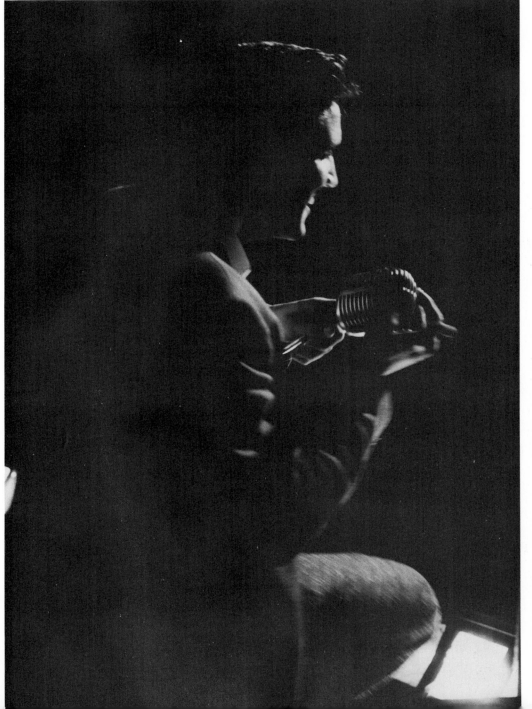

"I, I just wanna count the
blessings that this great domain
has bestowed upon her humble
son. My friends, this is a
man."James Dean in Giant.
The last movie Dean starred in
was released posthumously in
October 1956, only a month
before Elvis' first movie 'Love
me Tender' premiered at the
Paramount Theater in New York
City. Elvis had been a long time
fan of Dean's, enough of one to
be able to recite long stretches of
dialogue of 'Rebel without a
Cause' to Nick Adams, a friend
of both of him and Jimmy's.
Over the years we've come to see
them as kindred spirits, both of
them operating on a level of
intensity that set them apart from
all others in their respective
professions, a level of intensity
that will never be repeated
because their impact was to such
a large extent conditioned and
defined by the rigidity of the
world around them.

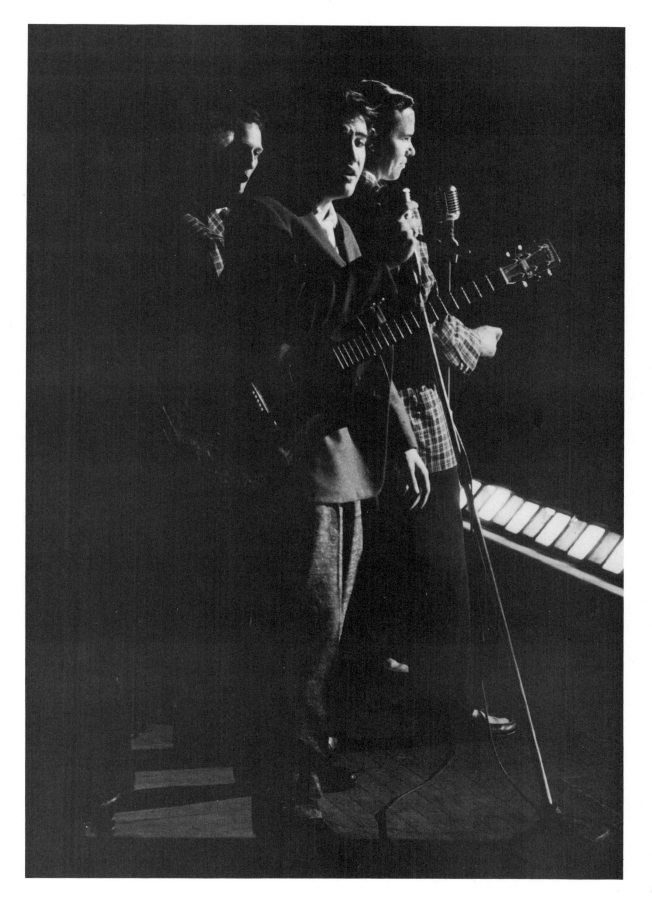

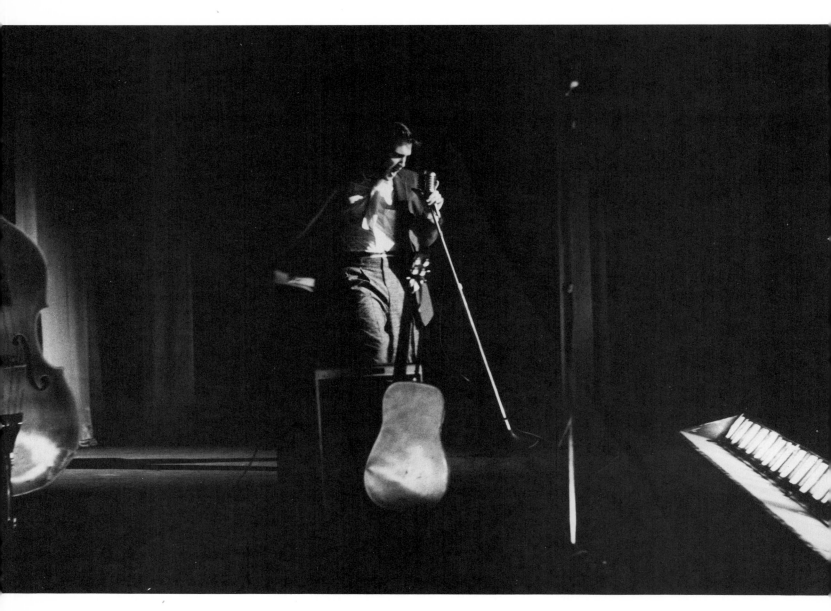

Perhaps more than in any other aspect both Elvis and Dean showed their distance from that world in the way they moved. Look at Dean moving over the dust road in Monterey at the beginning of 'Giant'. Look at Elvis onstage for his final Jacksonville show, there's a whole new poetry there with each gesture, each expression of the face and each snap of the leg spelling the freedom to do what you want.

But where Dean gives us an ambitious young man, brooding and torn inside, Elvis' brand of defiance comes out loud and faster than anyone can follow.

Here's rocking up a storm that's still raging after he has suddenly left the stage. And it takes a while for the crowd to realize he's really gone and for the screams to become a final pleading.

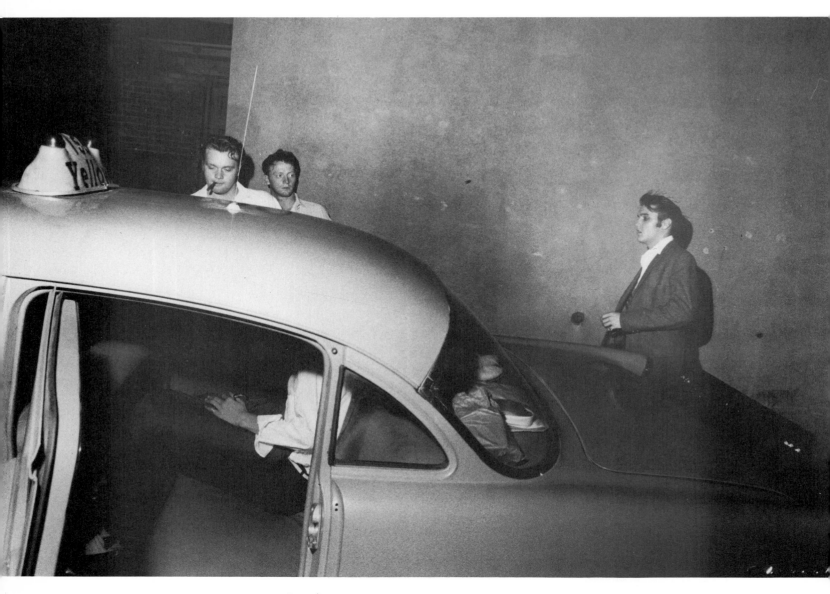

Jacksonville Finale.
As had happened so many times before, getting Elvis away swiftly from the theater after the performance presents no problems. There's a cab ready to take him to the hotel where he'll pick up his belongings and give some more quick interviews. It's late Saturday night and with the guy off their hands the policemen taking care of security around and in the Florida State Theater can shake their heads in disbelief, say to each other ''Nothin' like it since Sinatra started, I don't see how these kids can get so excited'' and then finally breathe a sigh of relief.

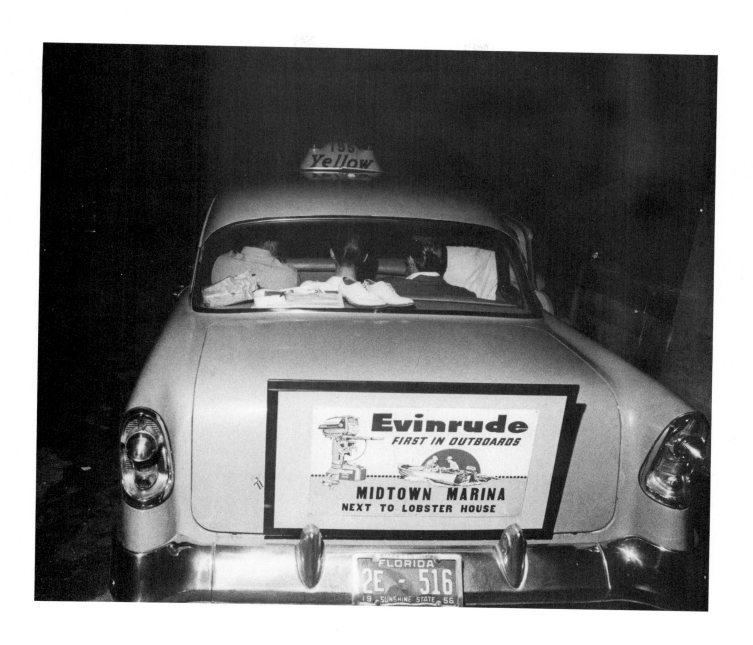

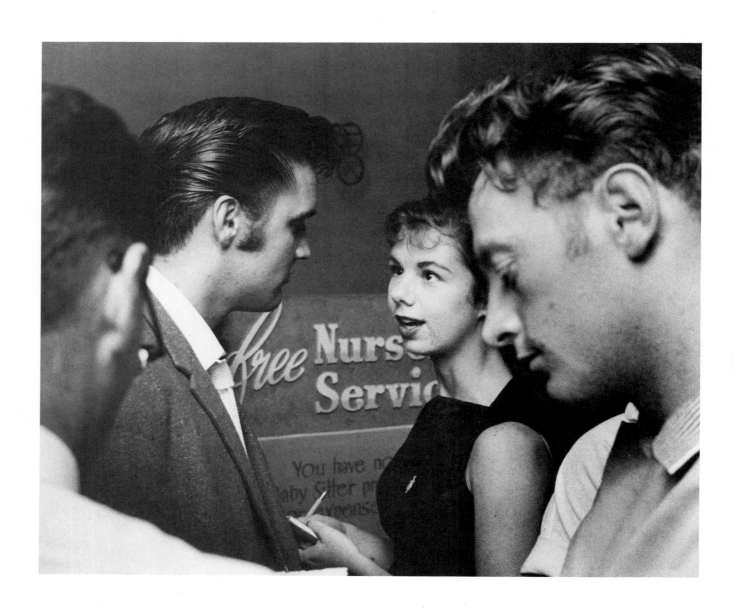

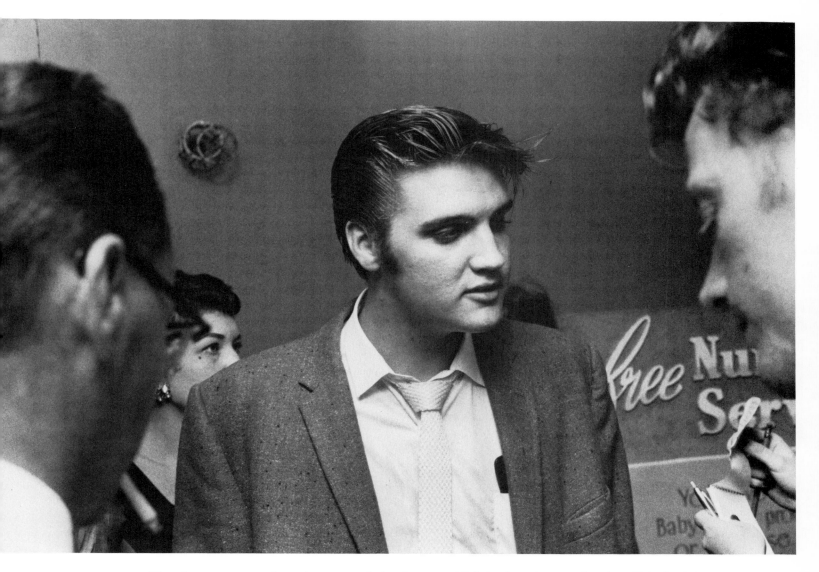

There's no prospect of rest for Elvis though, for the Colonel has decided it's better for him to travel by night to the next and final stop of the tour and for Elvis to get some sleep in the day time. Taking it all in his stride an obviously weary Elvis back at the Roosevelt Hotel answers yet more questions on how he feels about his success and what did the judge say and when will he be back again in Jacksonville? Elvis answers that he doesn't know when he will be back but as far as the confrontation with the judge went still appears bewildered. And like he's told other reporters after the first show he tells her again: ''I can't figure out what I'm doing wrong.''

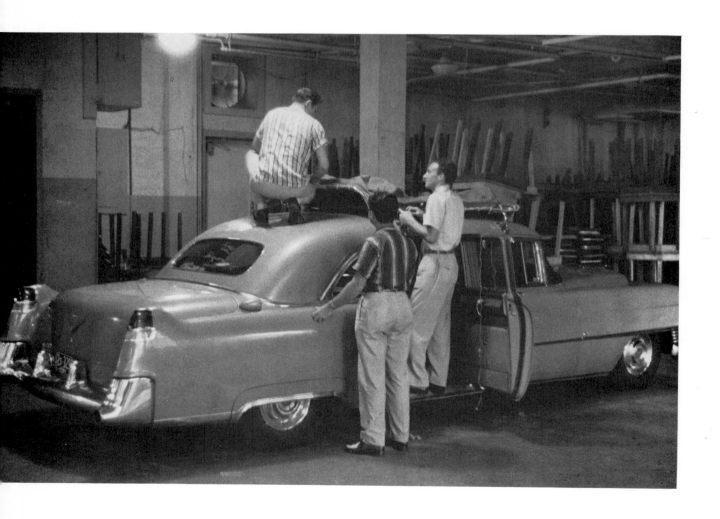

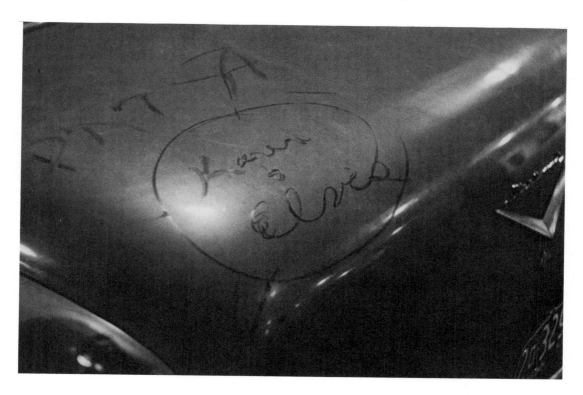

Meanwhile back at the theater Scotty, Bill and D.J. have almost finished getting themselves and the Cadillac ready for the long trip to New Orleans too. All that's left for them to do is haul Bill's bass on the roof and they'll be off, disappearing into the night with their car bearing lipstick traces of undying devotion.

You'll never know...
What heaven means...
Now the Lincoln
Continental in all its
lavender splendor may
be built for speed but
it's already late Sunday
morning when Elvis
gets out of the car,
having driven the last
stretch of the journey
from Jacksonville to
New Orleans himself.
The Southern high-
ways hold no secrets,
not even at night when
the white line unwinds
endlessly. Fatigue only
strikes after the ride is
over and all you long
for is a bed.

90

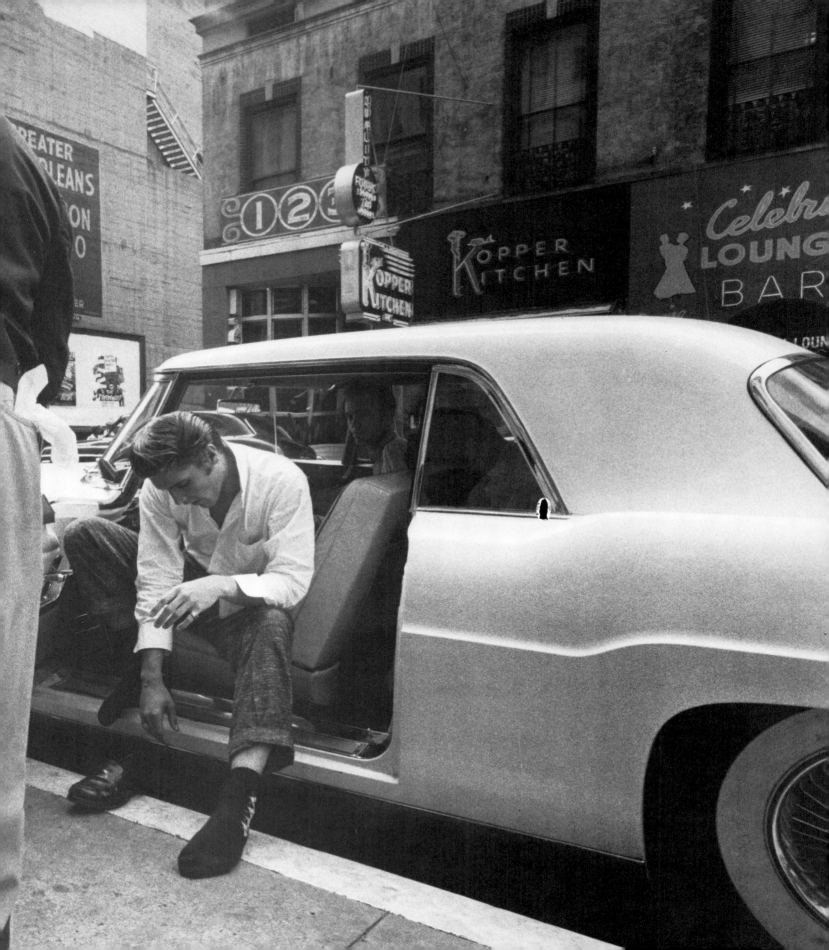

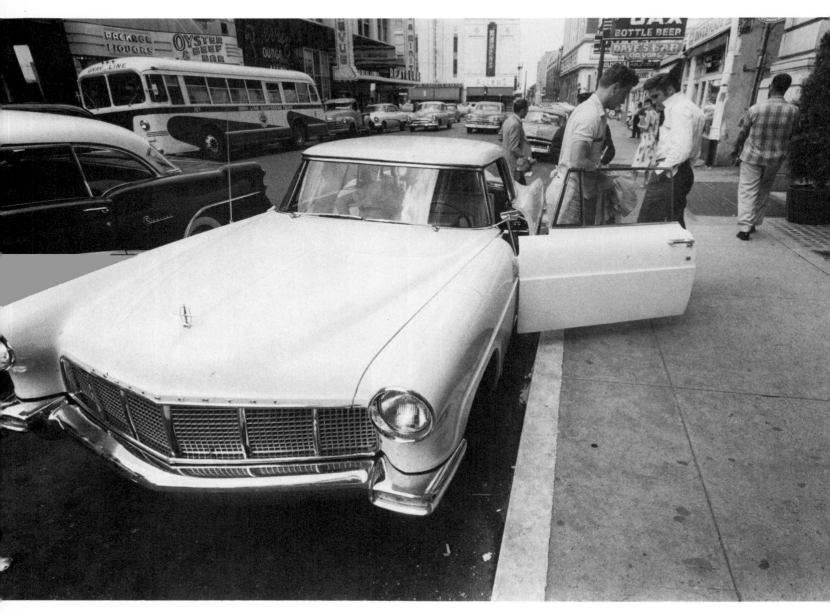

Before that can happen further formalities await, however, so Elvis in rumpled clothes that he's been wearing since the last show in Jacksonville ambles into the hotel and up towards the desk in the lobby and there leans over drowsily to check in. Sure enough the desk clerk and bell hop are dressed in black but they keep a quiet distance yet remain curious with this guy they've heard and read so much about. Here he leans on the counter, signs his name in the register with only one thing on his mind and that's hitting the sack.

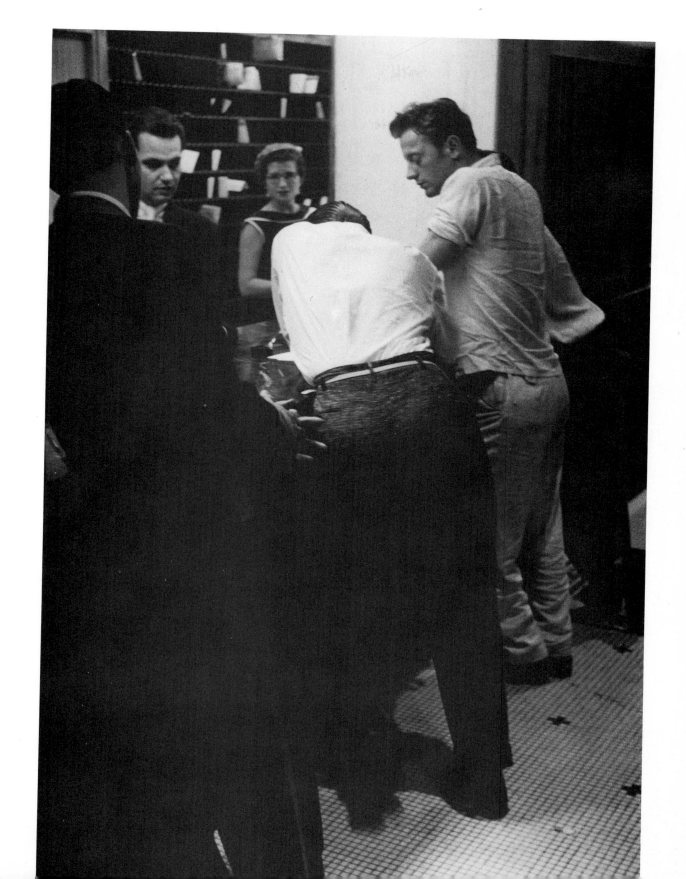

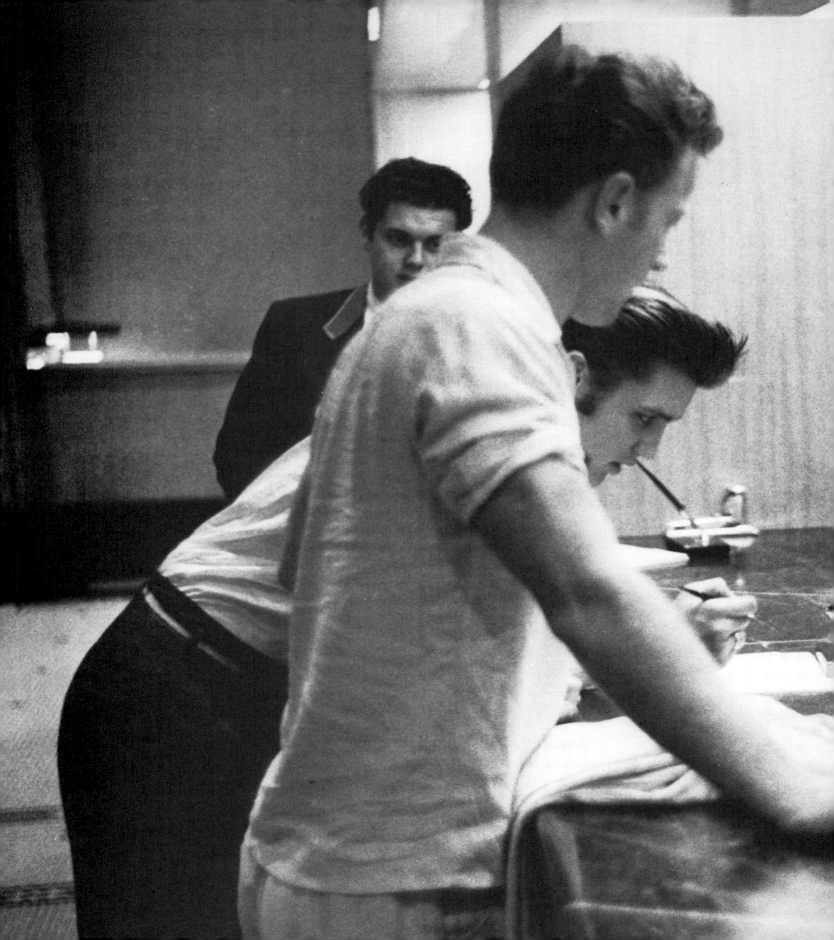

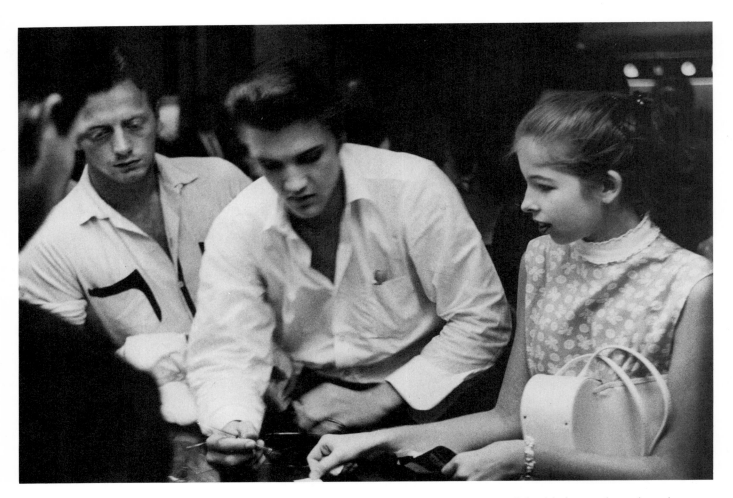

My, it's been a long time since he last felt cool, clean sheets, more than 24 hours in fact, and yet he obliges when one more fan overcomes her trepidation and hurries to the desk to ask him for his autograph. And then to sleep, perhaps to dream of never being allowed to make another move on stage again, or perhaps to dream of going down a dark and lonely and endless highway, driving a beat-up ole truck.

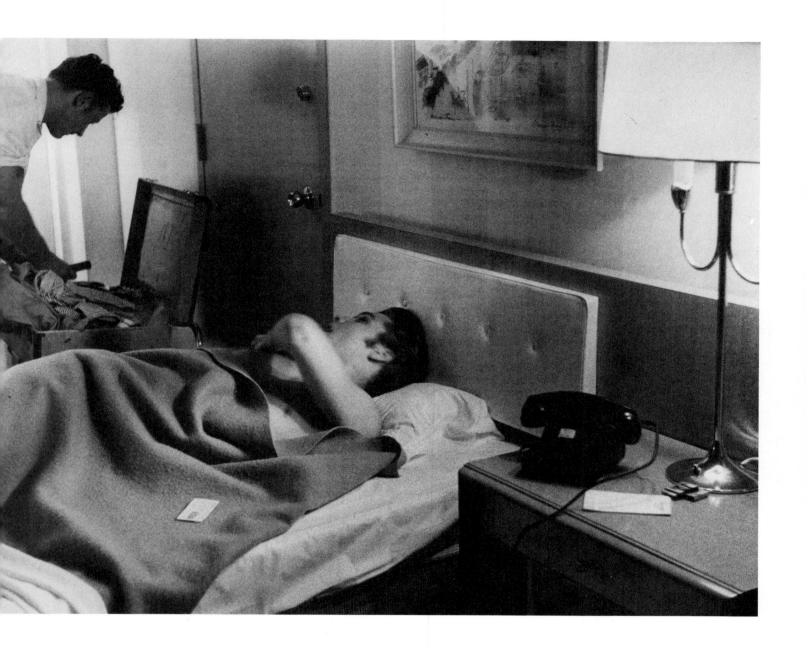

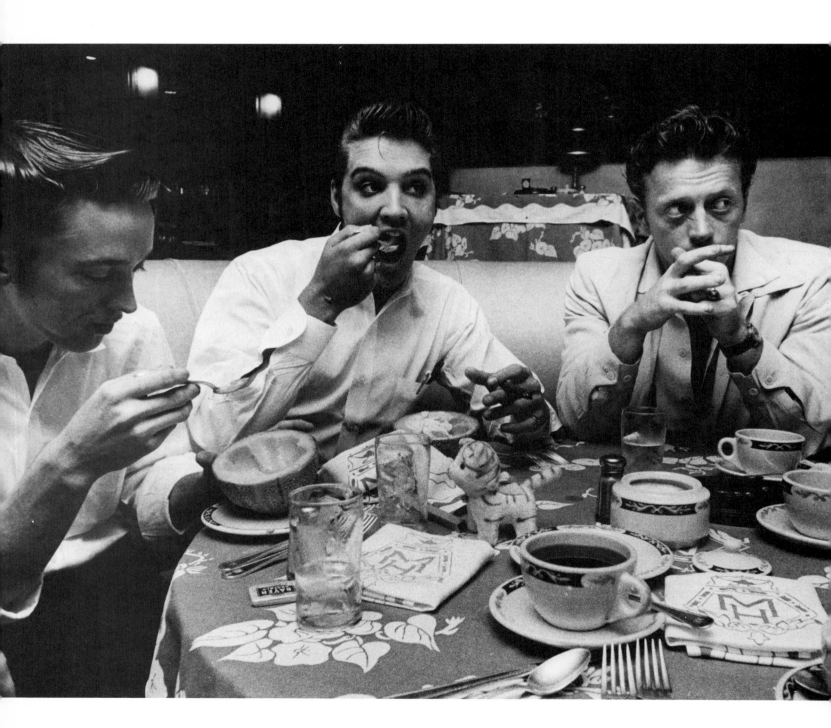

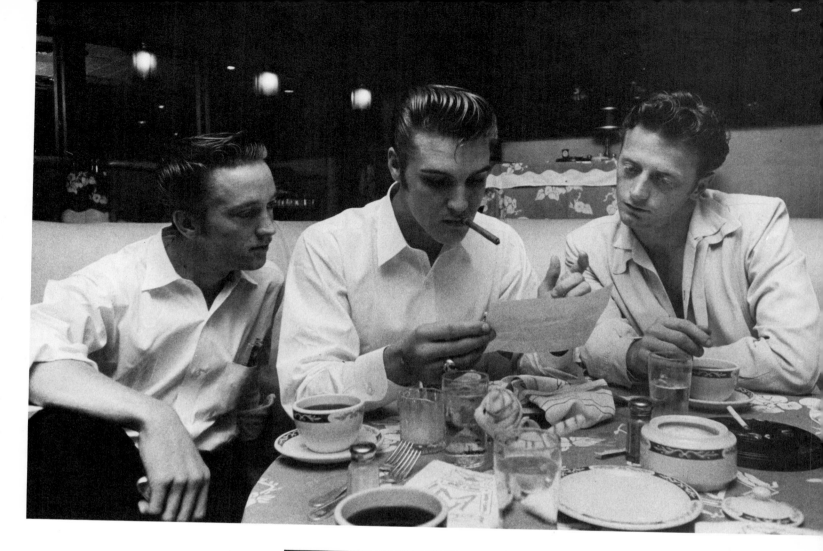

Showtime in New Orleans.
At around dinner time Elvis in
the company of Red West and
his cousin Bobby Smith has what
amounts to Sunday breakfast,
lunch and dinner all rolled into
one. There's plenty of coffee
around but Elvis sticks to milk or
water and a quick bite of melon
to eat before lighting up one of
his favorite thin cigars. They've
all put on clean shirts in anticipa-
tion of the upcoming show at the
Municipal Auditorium. Talk is
subdued with Elvis just out of
bed and already having to wind
up for the only evening
performance.

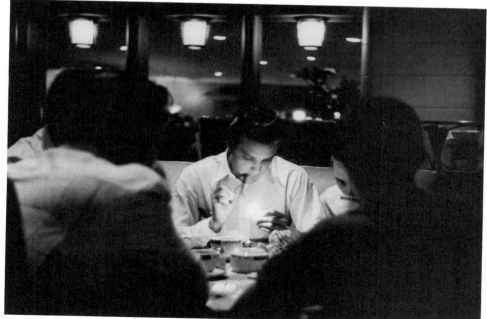

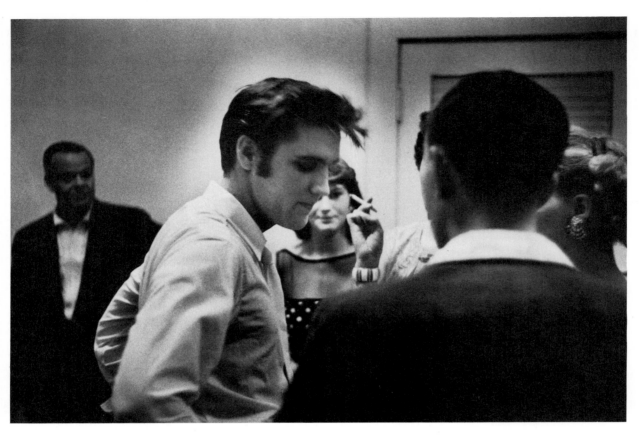

This is a show with a difference, however, because he'll be working two crowds at once by roaming 'cross a double stage. Someone's told him that everyone expects it to be a great turn out, well over then thousand as a matter of fact. Also at the theater waiting for him will be a girl he's invited to come see the show with her mother. His date is there all right when he enters the dressing room and she's really put the earrings on for the occasion. Her name is June Juanico and she's come over from Biloxi, Mississippi, having known Elvis well from when she was first invited back in April to join him during his stay in Las Vegas. A month before this New Orleans concert they'd spent time together too when Elvis had a holiday at the Gulf Hill Dude Ranch in Ocean Springs, Mississippi.

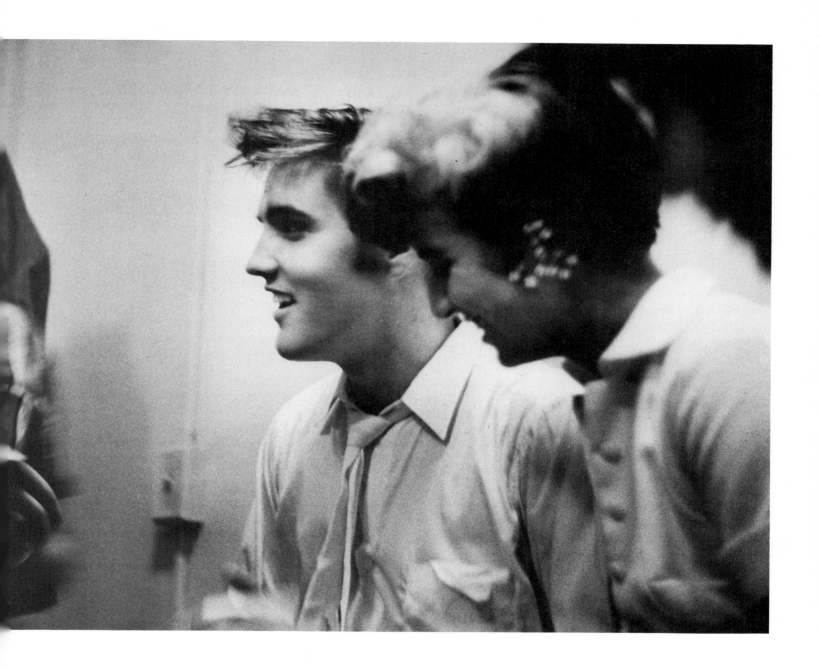

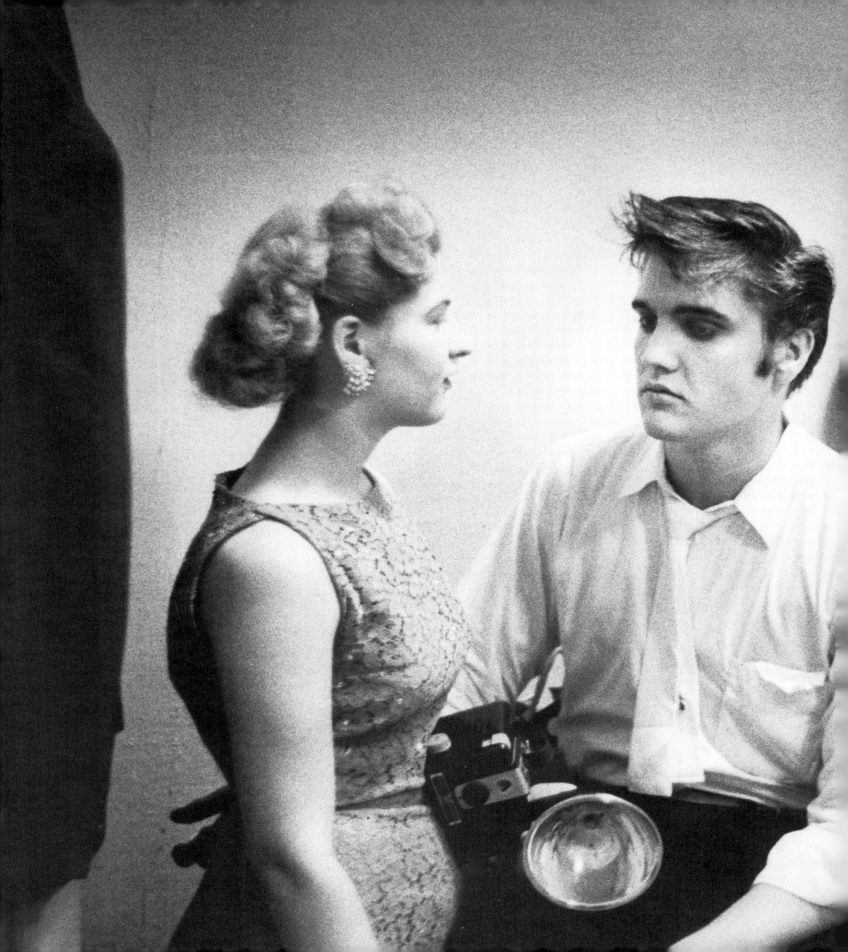

They spent enough time together anyway for rumors to reach the press that there might be a wedding in the offing. In a couple of radio interviews after that Elvis had gone out of his way to deny all the rumours saying she was just a good friend. It's not as if he's got a lot of time for her or her mother now though, so the pair of them sit with their backs to the wall and take the whole thing in with apprehension. And while Elvis talks to reporters, fans and all others crowding round in fierce competition to get just a word from him or a picture of him out on the stage the show that's part of the deal rolls on leisurely.

103

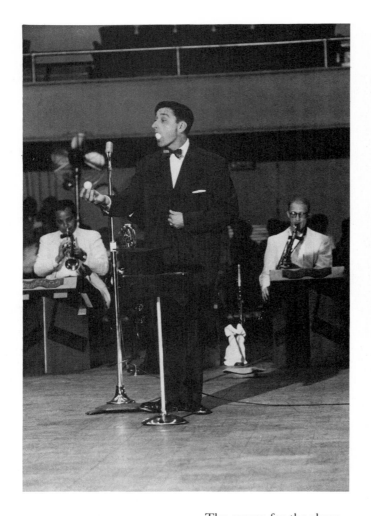

The emcee for the show, Tampa's own Frankie Connors, has also openend it with some songs. After that the crowd has had to stomach singer Nancy Ford (Nancy who?) and the instrumental group The Head-liners until they warmed up some to the mellow tones of The Jordanaires. Then finally it's comedian-magician Frank Maraquin's great moment to try and entertain a crowd of 13,000 who've only come out to see just one man. ("Now I got a ping pong ball, now you see it, now you don't!")

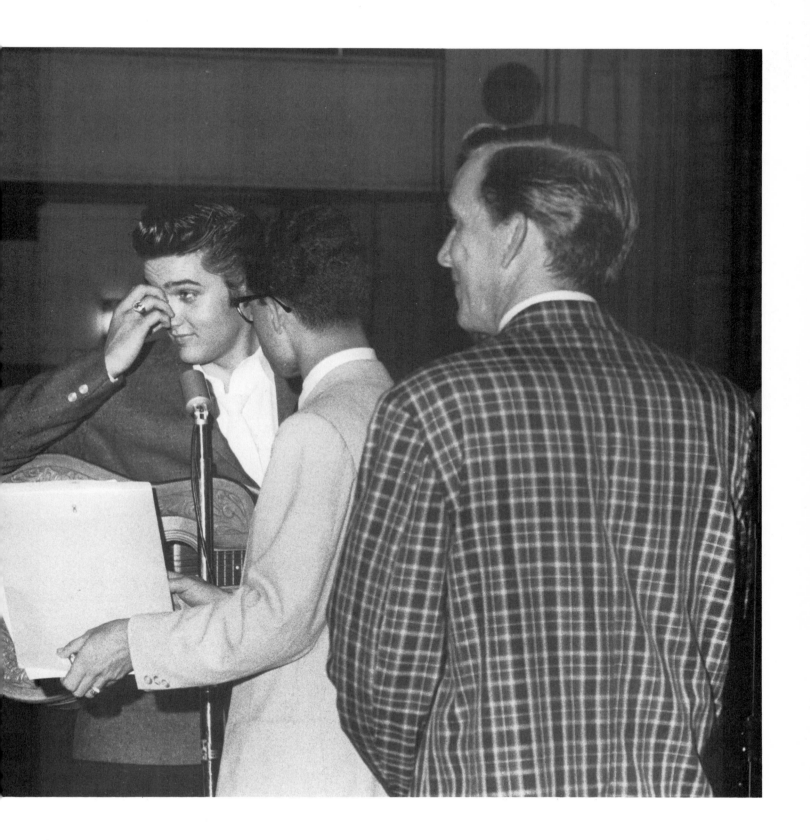

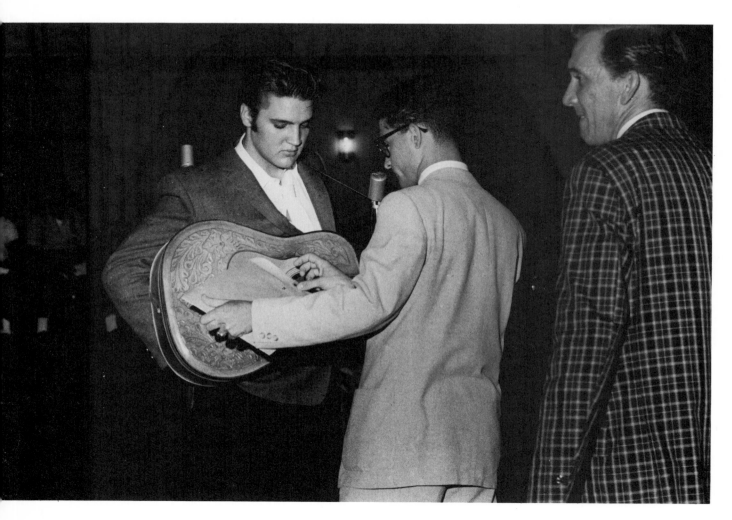

Then when Elvis finally steps on the stage after nearly two hours of the Colonel's idea of a variety show someone has to present him with something or other and nobody gives a damn what it is as long as he gets going with his act. From behind the curtains June and her mother watch as the crowd gets their money's worth at last.

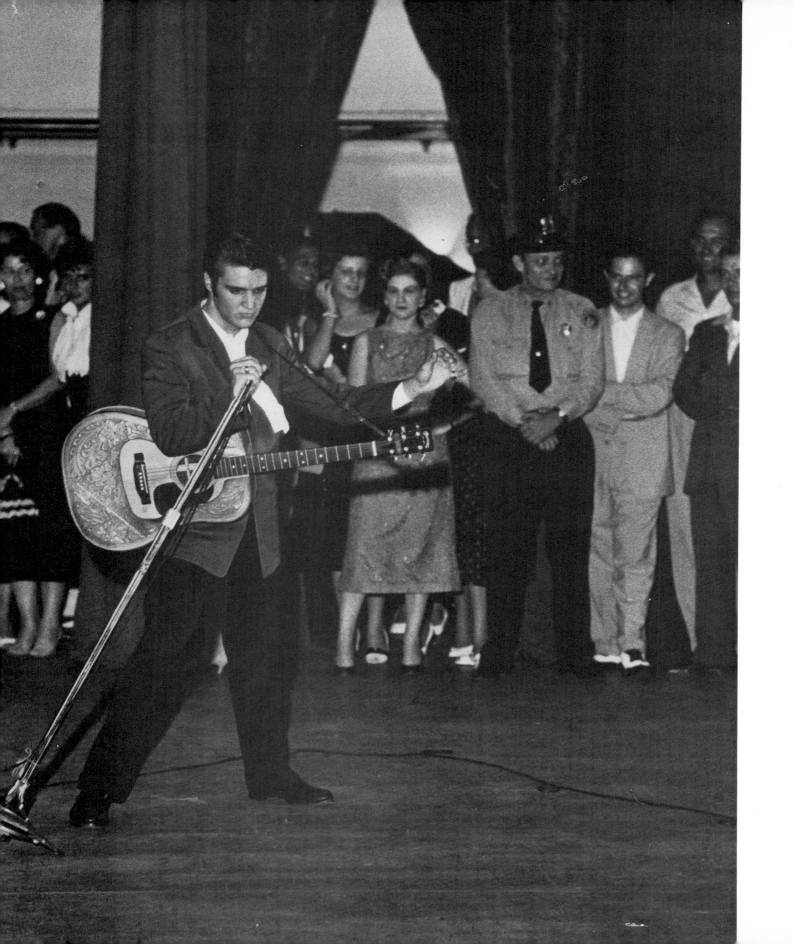

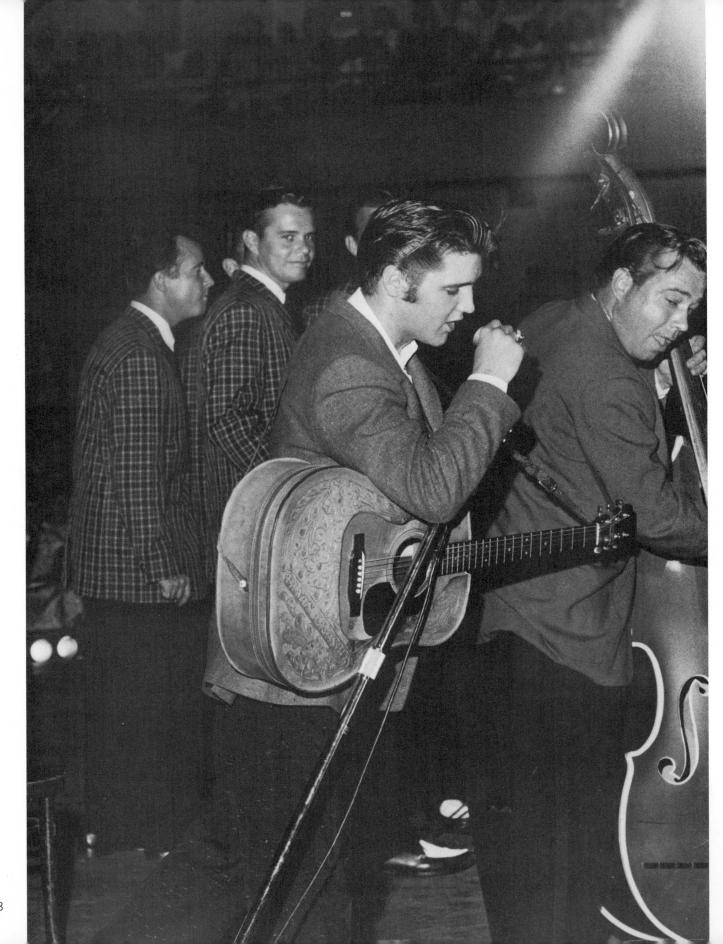

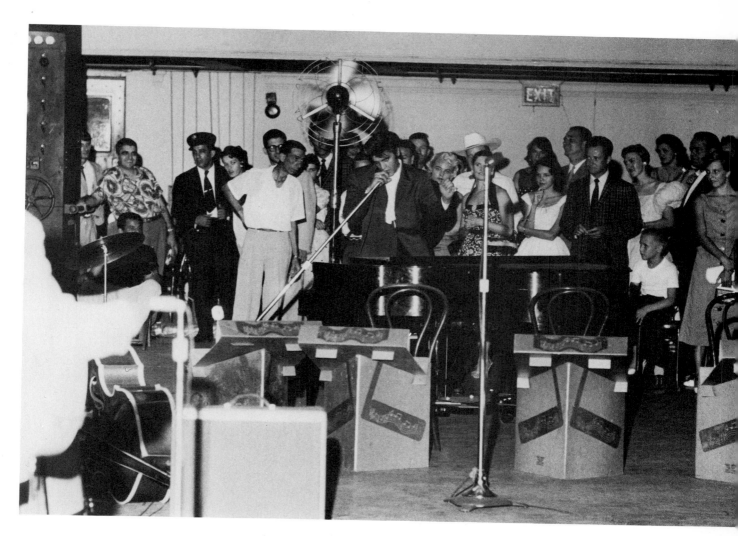

Just so things won't get steamed up too much the management has thoughtfully provided air-conditioning on stage. So facing two audiences, one on the left and one on the right and a whole bunch of local dignitaries, reporters and guests at the back of the stage Elvis gives it to them, shaking and roaming around as if he's all by himself. And they love it. Why, even the older folk backstage are having fun, whether it's because of the unflagging shrieking of the kids or Elvis' antics while he goes through his repertoire.

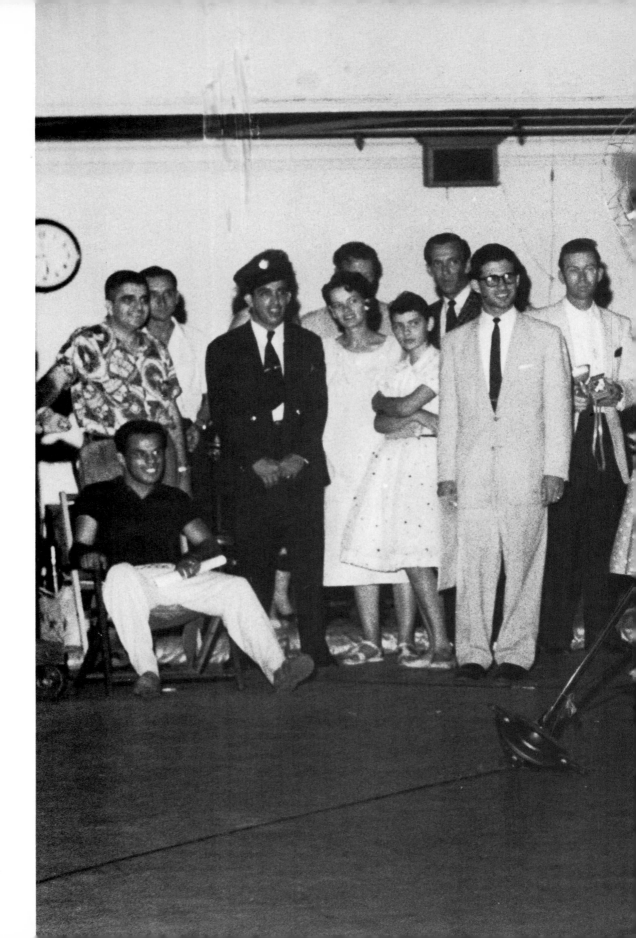

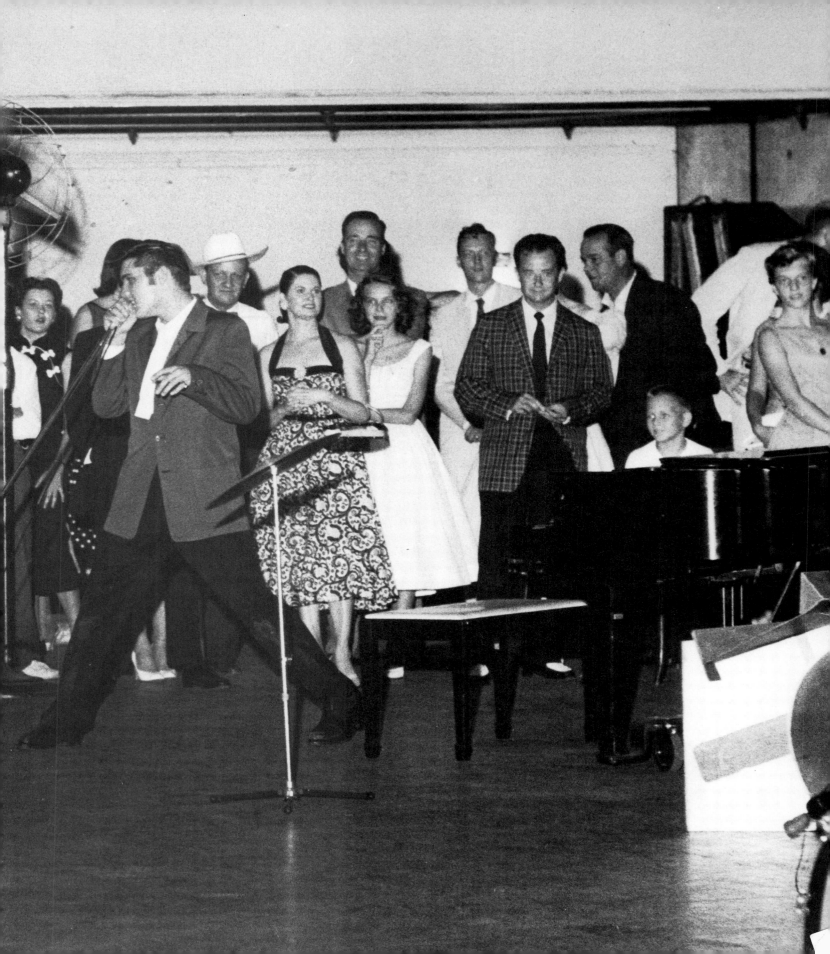

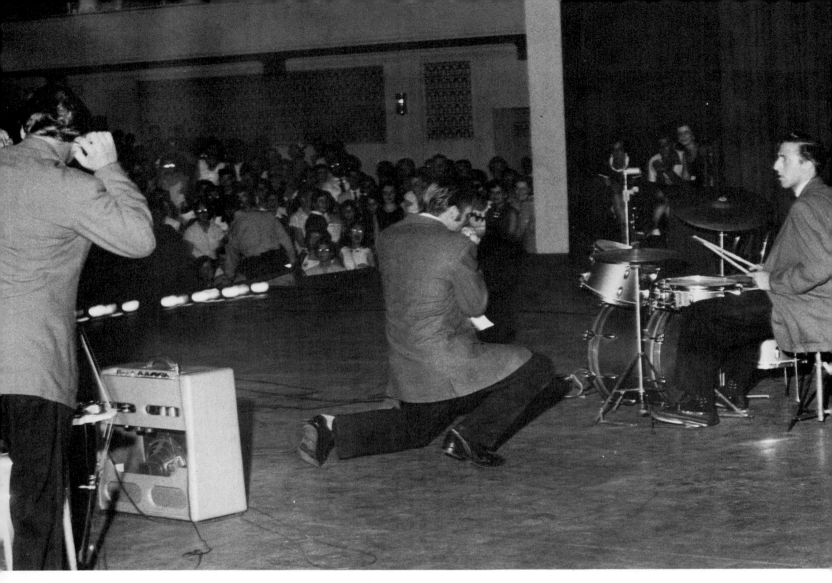

He drops right down on his knees as he sings of how he taught her how, then when the song's over tears right into the next one about a woman who does know how to treat him right. And the band thunders on with Scotty's blistering guitar continually on the edge of distortion and Bill working his bass as if he's chopping wood. And when there's an instrumental break Elvis pulls out all the stops like Jacksonville has never happened, like the whole Florida tour from Miami, through Tampa, Lakeland, St. Petersburg, Orlando and Daytona Beach has been forgotten and the judge was just a bad dream.

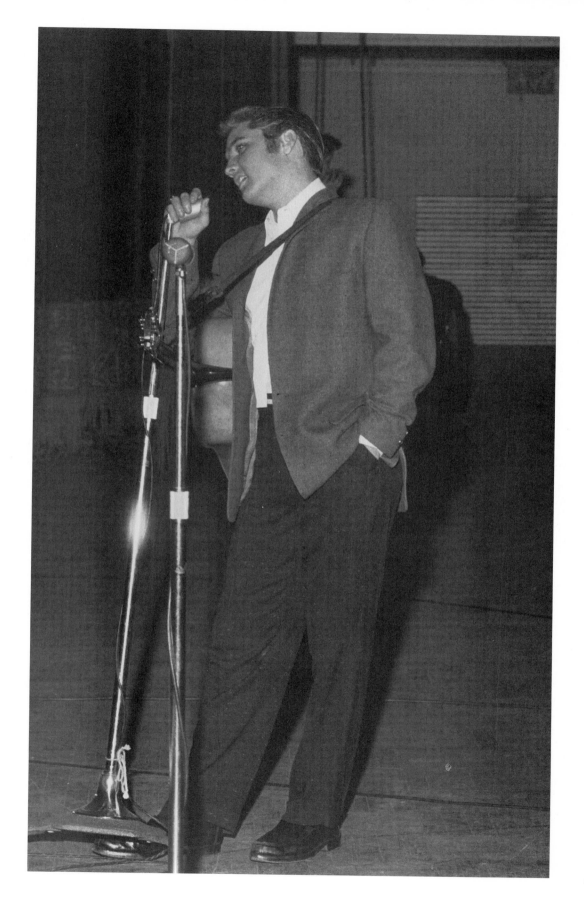

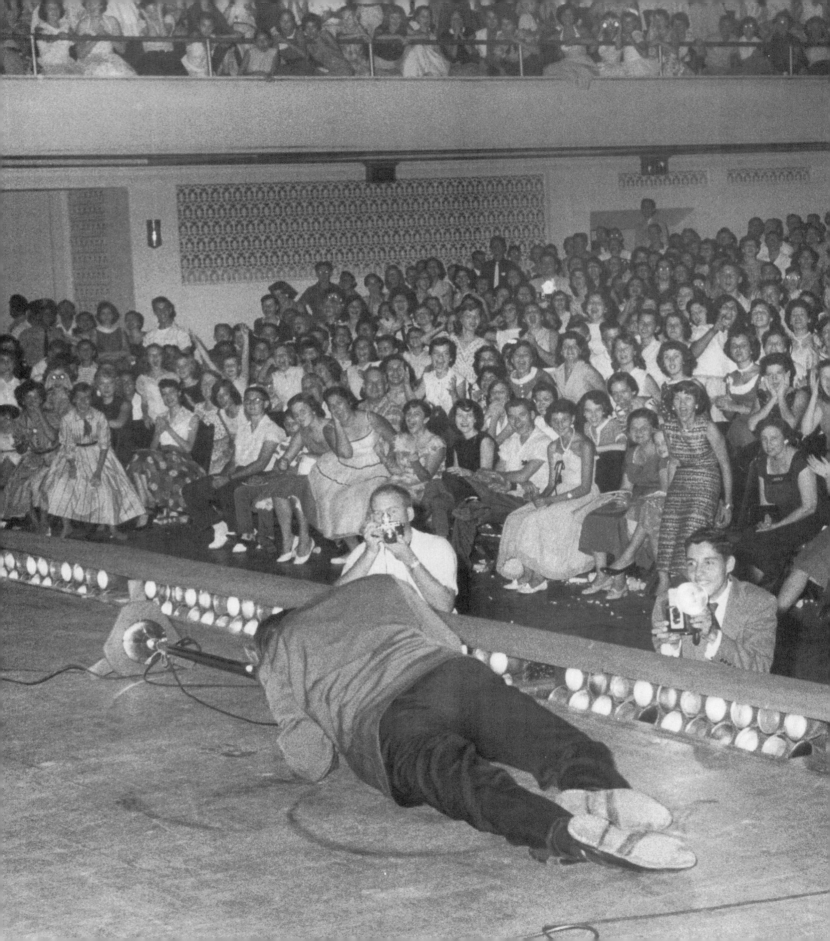

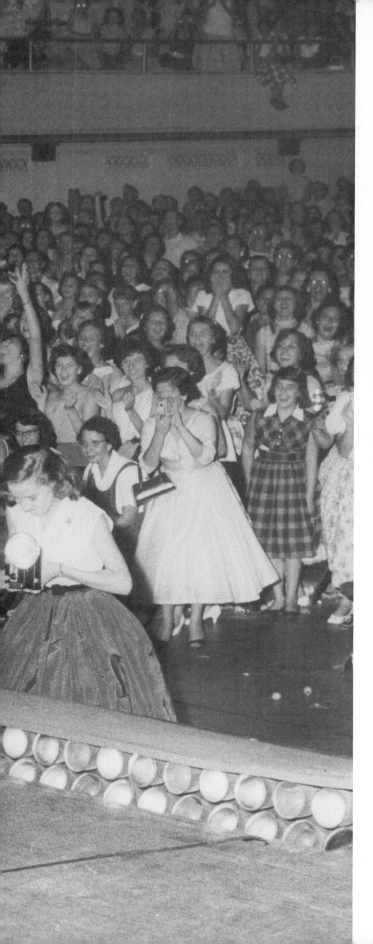

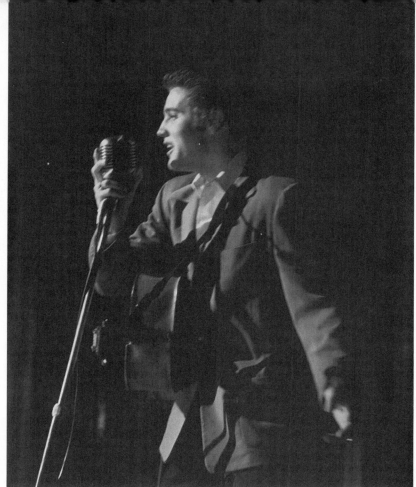

That sweltering month, August, 1956. Although the number one hits were building and Elvis had made appearances on the Steve Allen show and earlier that year on Tommy and Jimmy Dorsey's *Stage Show*, nothing could prepare America for the three Ed Sullivan shows, the first of which would be a full body shot (the "waist up" shot would come in 1957) on September 8, just three weeks away. After those shows until his induction into the Army in 1958, Elvis was *the* undisputed national superstar.

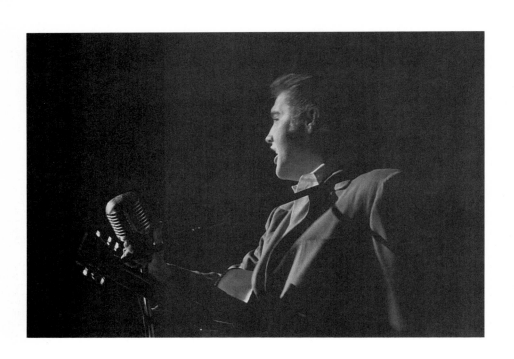

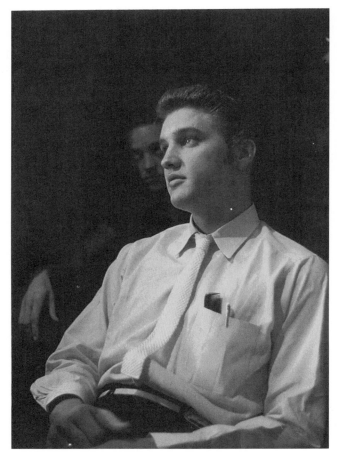

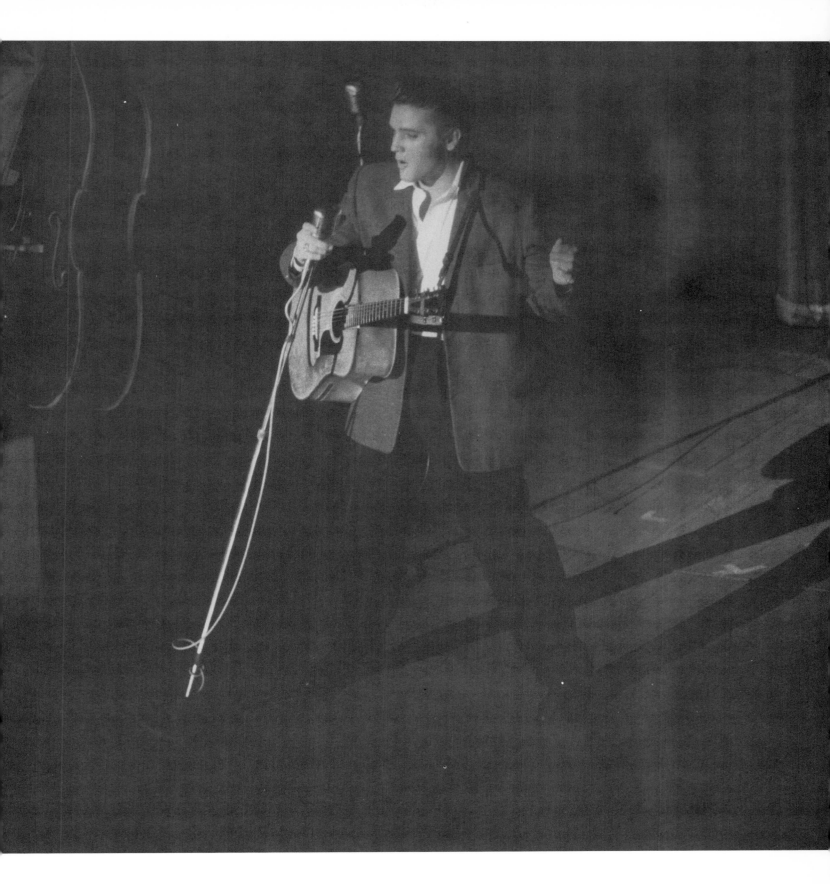

Elvis remembers his days at Humes High School in Memphis: "Nobody knew I sang. I wasn't popular in school, I wasn't dating anybody. In the eleventh grade they entered me in another talent show. I came out and did my two songs and heard people kind of rumbling and whispering. It was amazing how popular I was in school after that."

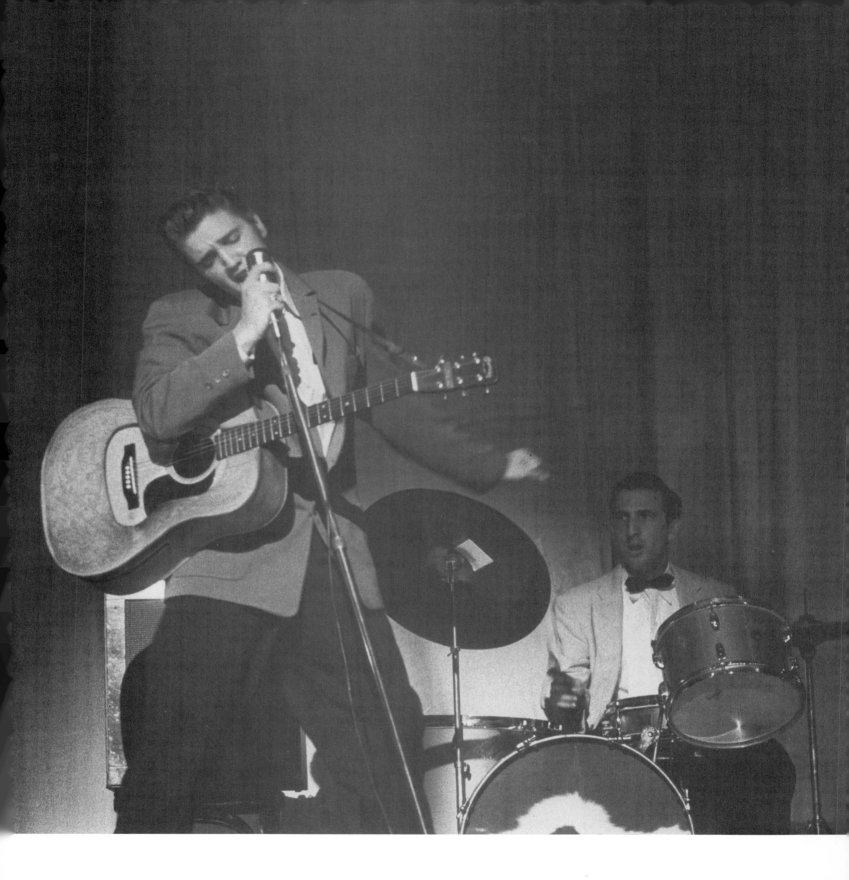

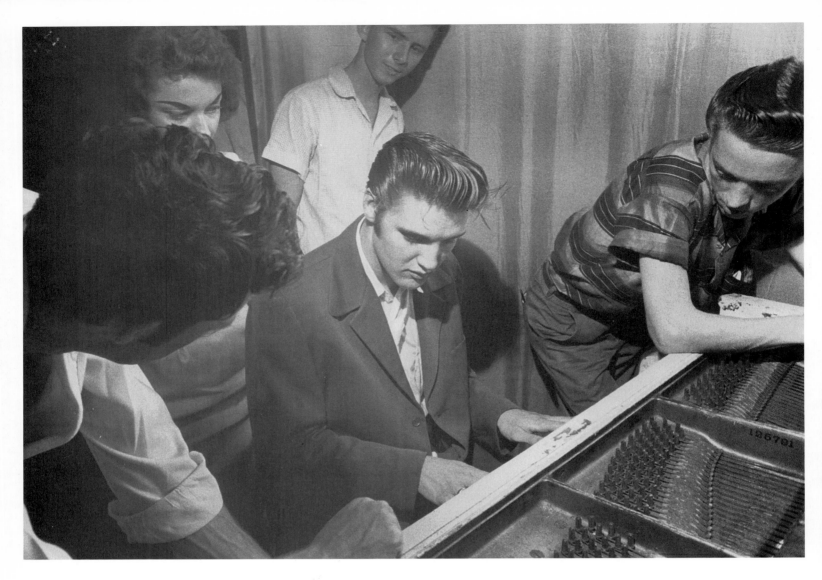

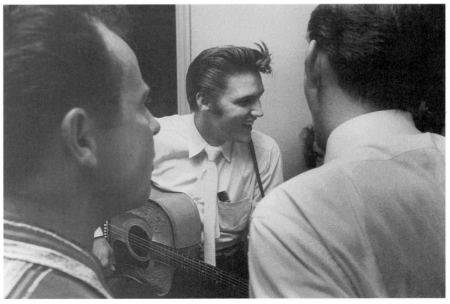

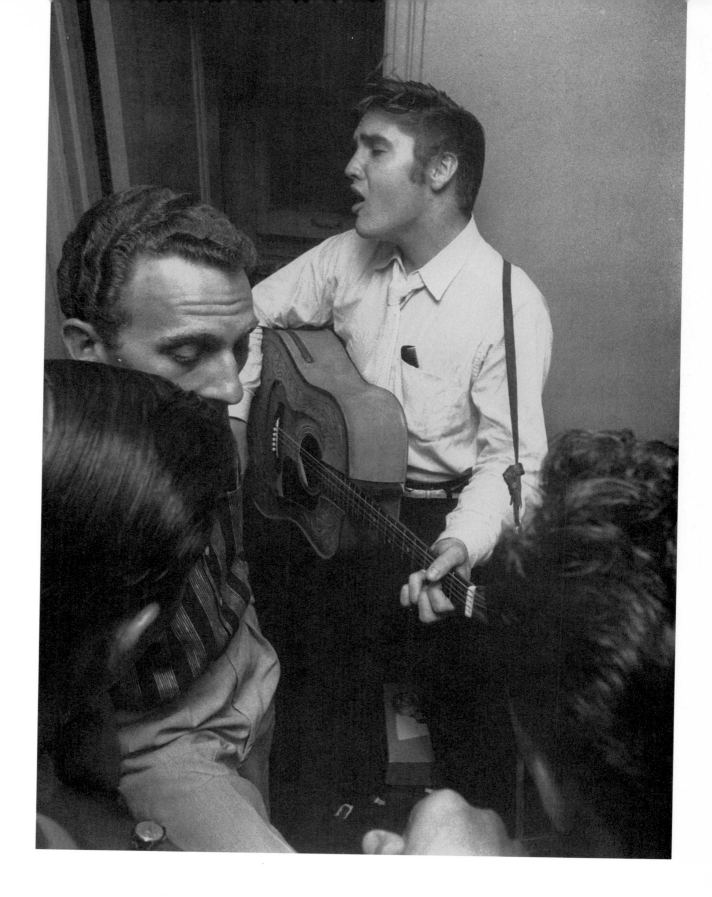

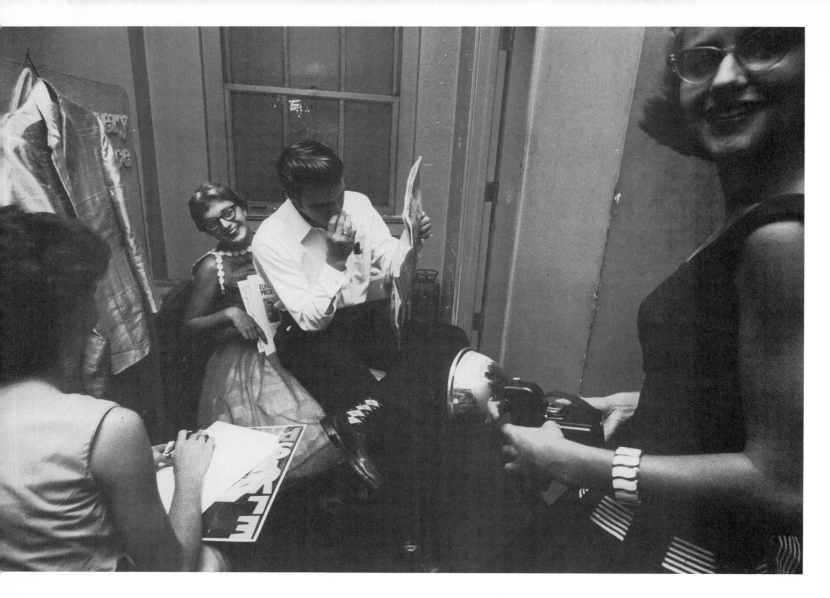

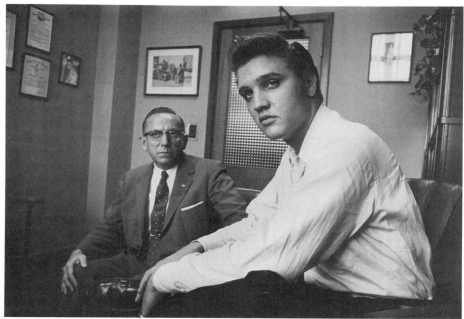

Out of RCA's studio in Nashville, January, 1956, came Elvis' first number one hit, "Heartbreak Hotel." The number one hits that followed in that same year: "I Want You, I Need You, I Love You," "Don't Be Cruel," "Hound Dog," and "Love Me Tender." Not bad for a twenty-one-year-old kid.

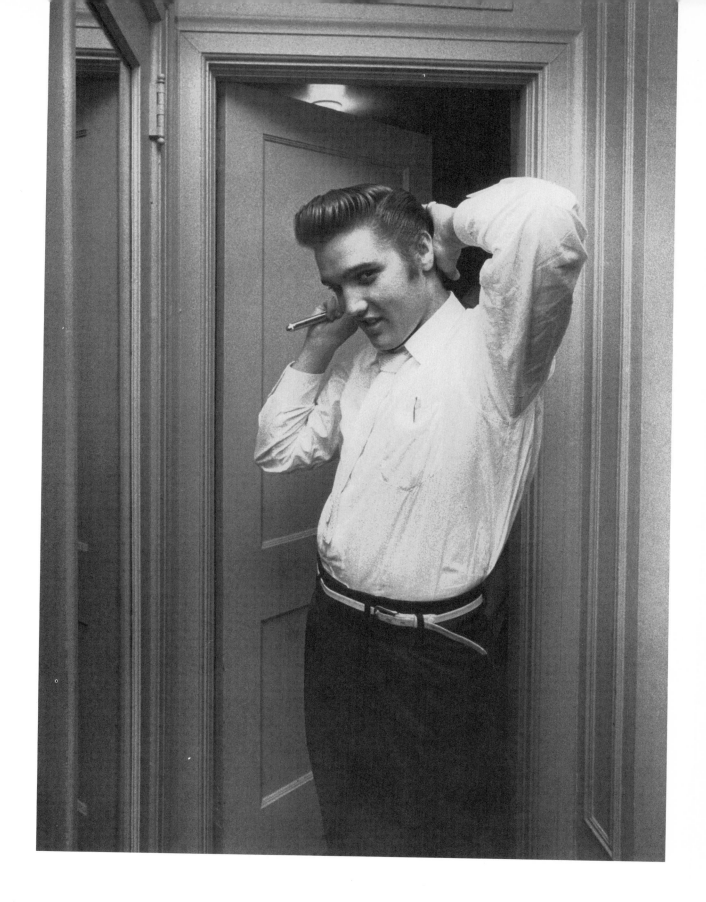

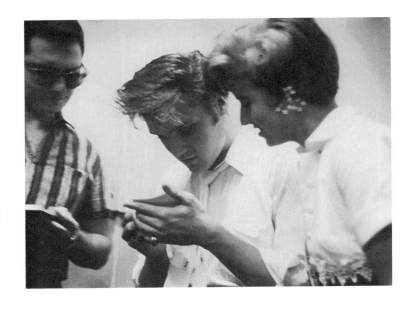

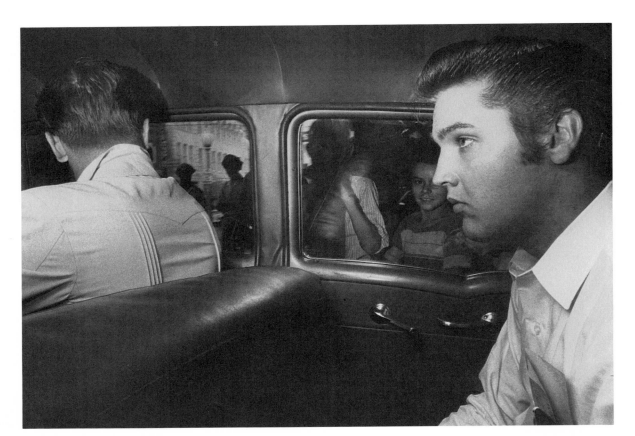

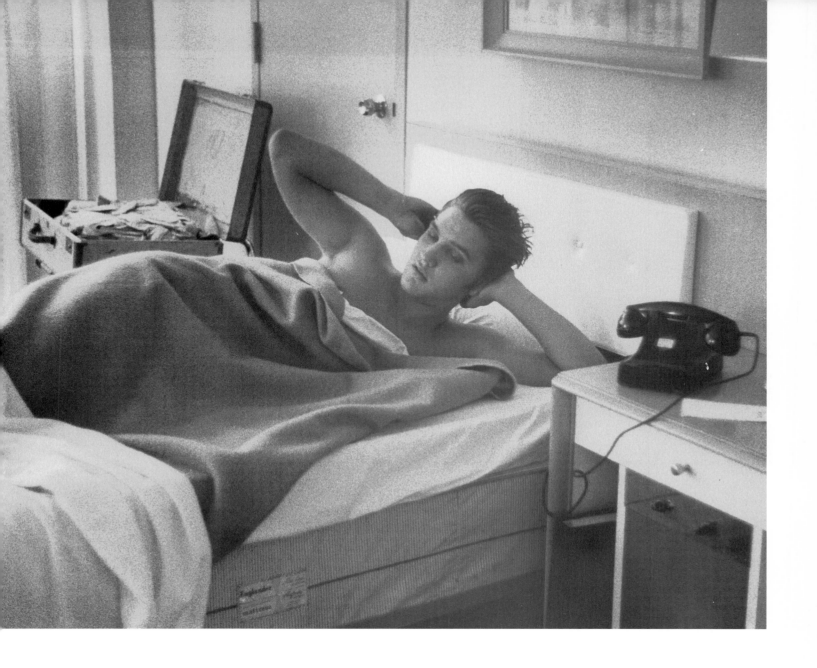

"Without Elvis Presley none of
us could have made it."
 —Buddy Holly

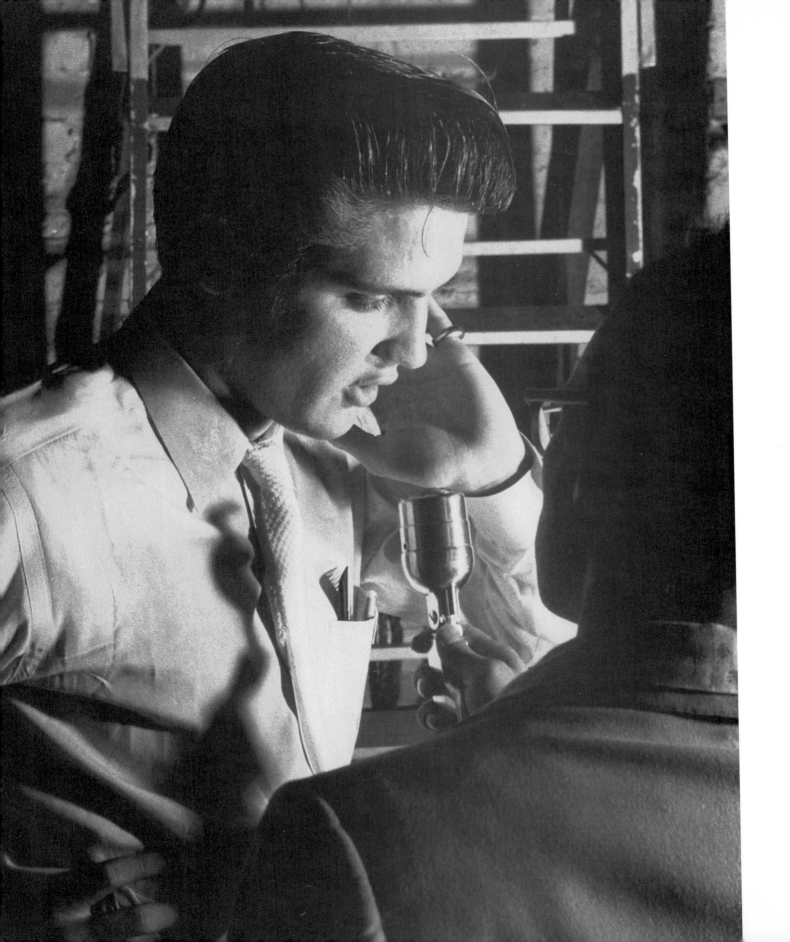

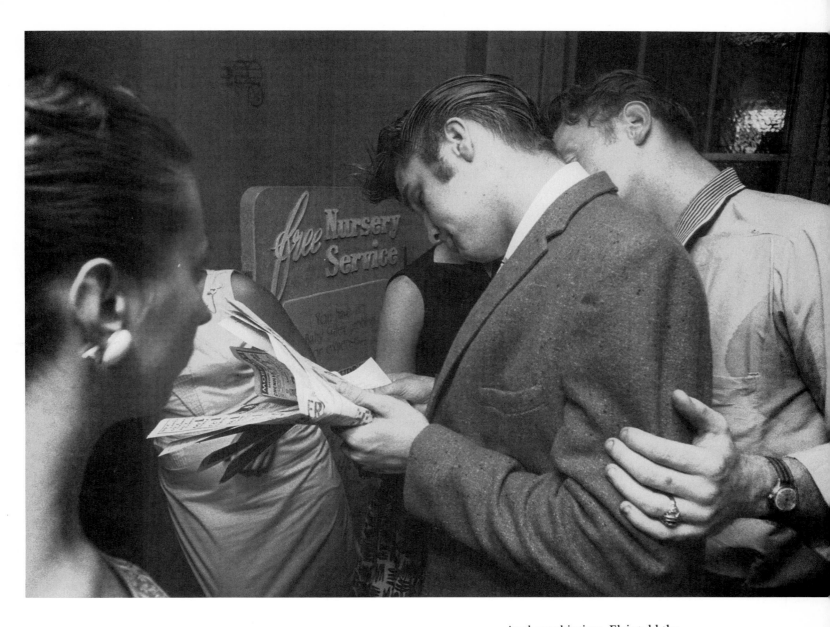

At about this time, Elvis told the *Saturday Evening Post,* "I just fell into it, really. My daddy and I were laughing about it the other day. He looked at me and said, 'What happened, El? The last thing I can remember is I was working in a can factory and you were driving a truck.' We all feel the same way about it still. It just... caught us up."

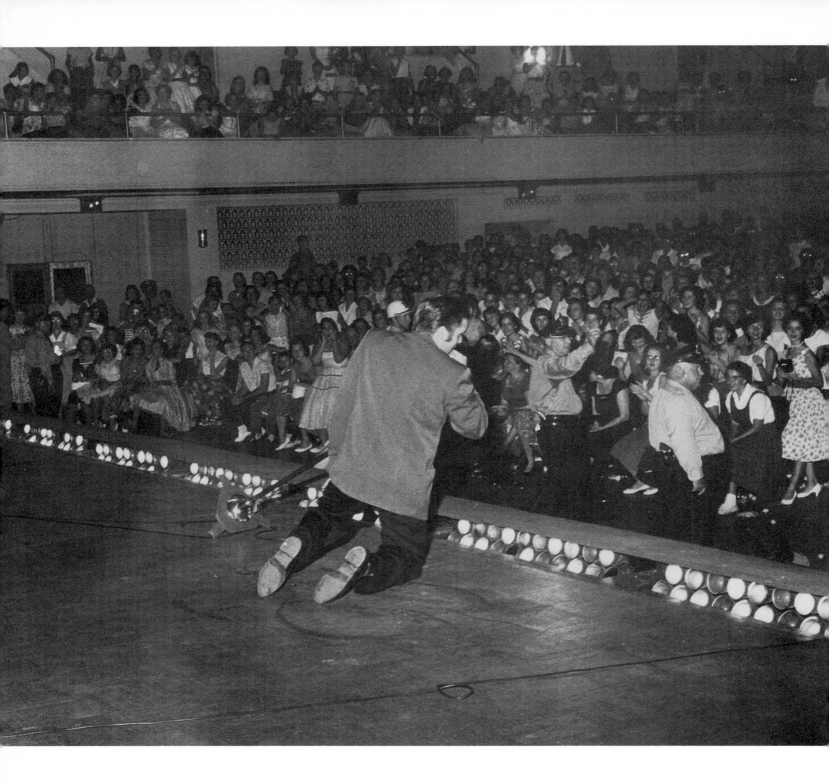

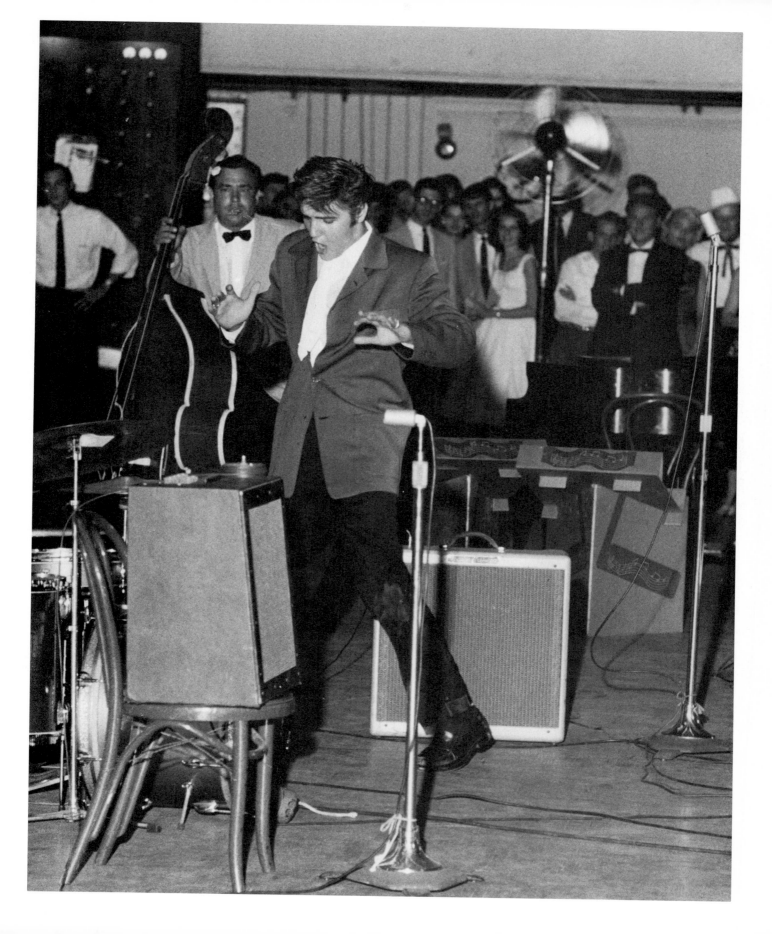

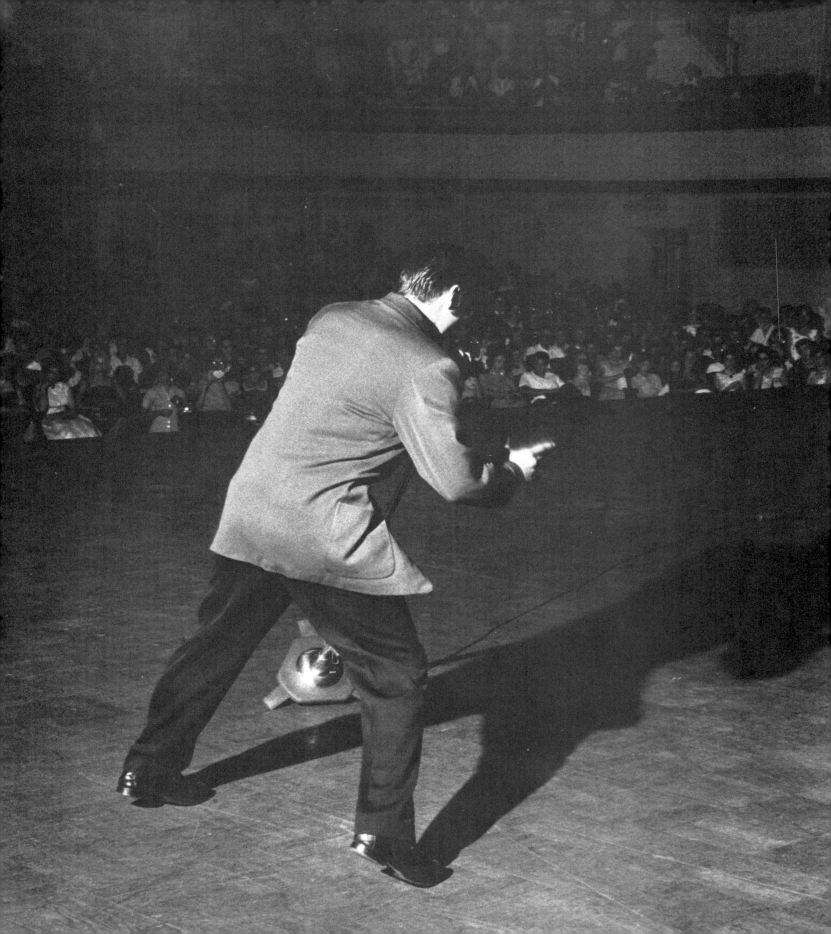

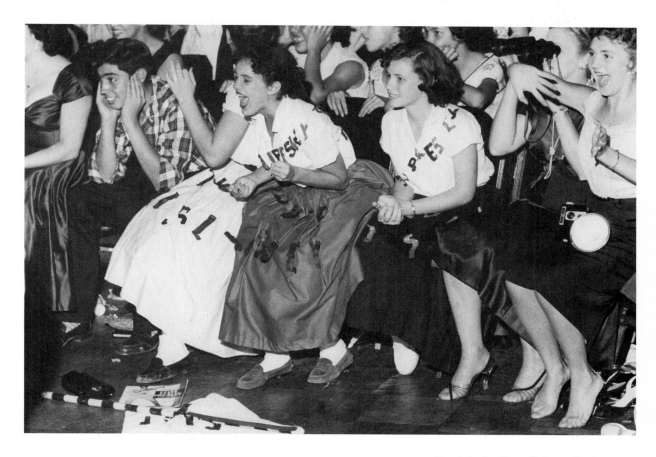

Tonight in New Orleans isn't a
dream, not for all of them who've
come out with his name all over
their clothes and his name on
their lips all day.

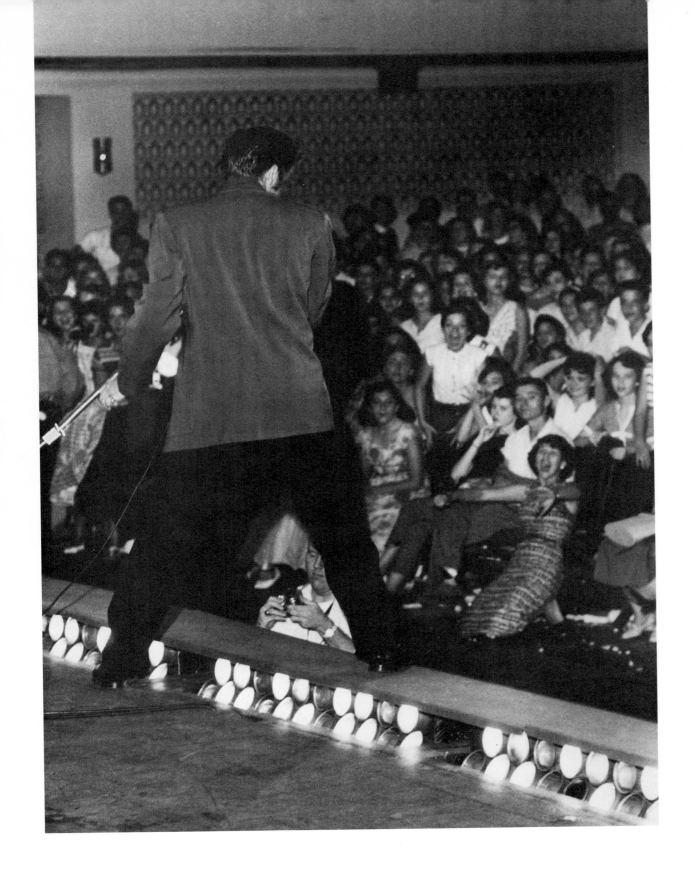

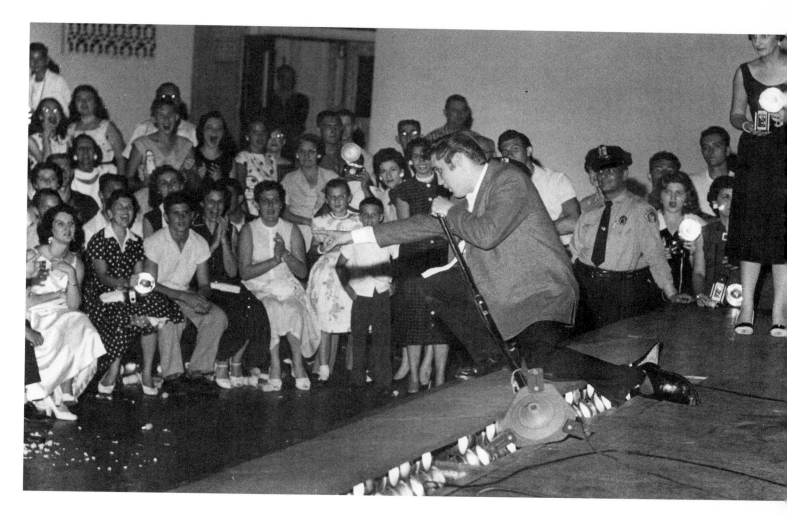

Like all the fans going out to see
Elvis performing in 1956 they've
waited for so long that now
they'll pull out all the stops too
and they scream till it hurts.

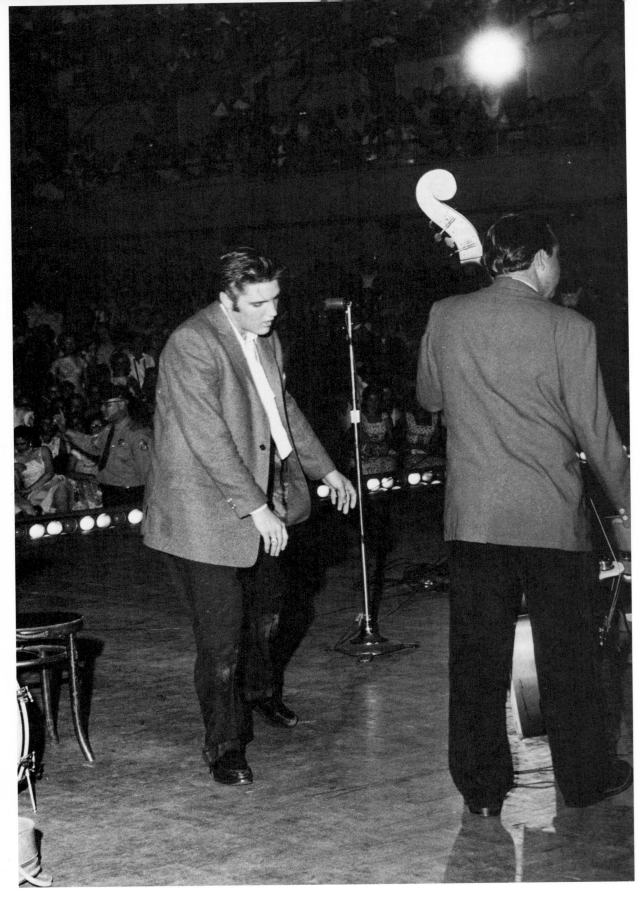

All of them will remember this show for the rest of their lives. On the stage, caught in the spotlights, he laughs at himself, at them, at the whole darn thing. Although he's right in the middle of it and has travelled one hundred thousand miles in the last twelve months alone and feels ten years older for it, the thing's still a mystery and all he can do is go where it takes him, for as long as it lasts.

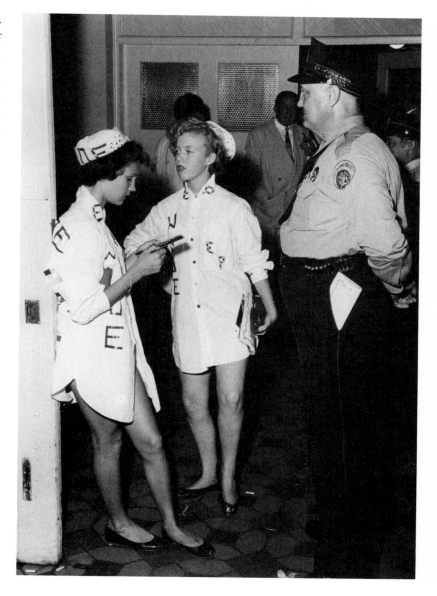

ABOUT THE CONTRIBUTORS

Jay B. Leviton is an internationally known photographer whose work has appeared in *Time, Life, Sports Illustrated, People, Newsweek, Money, Fortune, U.S. News and World Report, Forbes, Ladies' Home Journal* and numerous other magazines.

Ger J. Rijff is the publisher of Tutti Frutti Productions based in Amsterdam, Holland.

Kurt Loder is a former Senior Editor of *Rolling Stone* and currently the MTV news anchorman. He is the coauthor of the best-selling *I, Tina.*